Get that Picture

Robert Bowden

AMPHOTO
American Photographic Book Publishing Co., Inc.
Garden City, New York

Library of Congress Cataloging in Publication Data

Bowden, Robert
 Get that picture.
 Includes index.
 1. Photography, Journalistic. I. Title.
TR820.B68 778.9′9′07 77-22064

ISBN: 0-8174-2430-X (Hardbound)
ISBN: 0-8174-2111-4 (Softbound)

Manufactured in the United States of America

Dedication

To Barbara, who always maintained the faith,
 To Dean and Lisa, sources of my happiness,
 To Comer and Frances, whom I can never repay,
 To Jack and Joan, who made an in-law feel like a son.

Acknowledgements

These pages always thank the large number of people who made a book possible.

But, a large number of people didn't make this book possible, except in the most abstract of considerations. Just a few individuals stand out.

Bill Steven stands out, for instance. This man from Sarasota, Florida, spotted a newspaper column I wrote on photography and thought it might be a help to photographers of the Harte-Hanks chain of newspapers. He asked for it and he received a weekly column aimed at professionals.

In this endeavor, Steven had the backing of Harte-Hank's president, Robert Marbut, who pays my salary. Thank you.

I owe my personal allegiance to the *St. Petersburg Times,* the newspaper which said, "Yes" to the whole arrangement. For that, I'm grateful to President and Editor, Eugene Patterson and Director of Illustrations, George Sweers.

Now, let's go back a little further. Several photographers helped me in the days when I was asking "what *f*-stop ya using?" Most helpful were Jack Belich, now chief photographer with the *St. Petersburg Times*, Fred Victorin, and Ron Wahl. All spent hours teaching this neophyte the world of photography.

I've had assistance from some very patient models in years past. None more so than Jill Shuler, the subject of the chapter on posing the model, and Jennifer Jester, Miss Manatee in the chapter on the photo essay. Thank you.

To all who have stood in front of my camera, exposing body and soul, thank you. To the kind people who give pit passes to photographers like me, thank you. To the newsmakers who grin and bear it, thank you.

And, finally, to my father, who sat a two-year-old son down in front of a typewriter and said to himself, "I'm going to teach him how to type." With patience, he did just that. At age three, the author was typing and copying, from works put in front of him.

I have never stopped typing and writing.

My father knew such would be the case.

I hope he is both proud and happy now.

Contents

Introduction

Where do you seek further guidance once you know what an *f*-stop is? What books can a serious photographer turn to for instruction beyond the basics? When I searched for the answers, I found a void.

I was joined in the search by the Harte-Hanks chain of newspapers. Seeking a way to educate their photographers beyond mere *f*-stops and elementary composition rules, they asked for a weekly column directed at the newspaper photographer.

From that column has come this book. While its contents were originally intended for use by professional news photographers, the information is nevertheless valid for the advanced amateur or college student of photojournalism.

There is as little order here as there is in the life of a newspaper photographer. What we offer is a collection of tips, if you will, on advanced picture taking. Each chapter is a lesson with a single message. Each chapter can be directly translated into daily usage by the newspaper photographer, or stored away for future reference when a pictorial need arises.

Photographic snobs say that a newspaper photographer's work is "quick and dirty." But newspaper photographers get the job done. And that, after all, is the name of the newspaper game. This book will help you toward that goal.

1

Choosing a Camera

Sooner or later, every photographer, whether the small weekly's editor-reporter-photographer or the daily's chief photographer, faces the bewildering choice of what camera to buy.

A brief glance at the range of cameras available through used-camera columns will probably only further confuse the prospective buyer.

For the amateur, the choice is far from simple. The only solution lies in carefully defining the outer limits of his or her photography, and then selecting the best camera money will buy to fulfill those needs.

But for the advanced amateur, semi-pro, and the professional, the camera ranks are much more closed. In fact, only a few companies offer cameras seriously worth consideration by the working press photographer. A full-system, 35 mm single-lens reflex camera is what's required. Interchangeable lenses, viewfinders, and backs, plus a full line of accessories will at one time or another be needed.

The camera I bought secondhand years ago has never given me a moment's trouble. But the choice of new or used is up to you and your checkbook.

Once you have selected a camera body, you must choose your lenses; one lens simply will not suffice. You cannot expect to do creative work continuously with the limited perspective of a "normal" 50 mm lens.

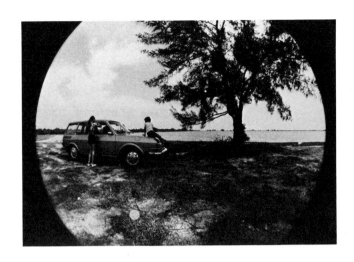

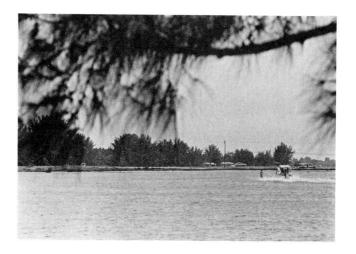

All of these pictures were taken from the same spot. Only the lenses were changed to show the differing angles and perspectives achieved. Taken with: 12 mm fisheye (top), 20 mm (center), 35 mm (bottom). Taken with 55 mm (top), 135 mm (center), 200 mm (bottom).

If an expensive body is chosen, it makes no sense to buy a cheap lens. Lenses determine picture quality through image sharpness. Good lenses are painfully expensive, but a used lens can be bought at a more reasonable price.

Stagger your purchasing of lenses according to your individual needs. Start with a wide angle of perhaps 28 mm. If you think you may ultimately buy more than one wide angle, then the 35 mm is a good first choice, with a 24 mm added later.

I use a 35 mm lens for 90 percent of my spot-news photography (and all of my strobe work except portraits). My other wide angle is a 20 mm.

Once a wide angle has been bought, the next consideration should be a telephoto lens. Almost all of my telephoto work (including portraits) is done with a 135 mm lens. If you can, the 135 mm is the one to own.

If you can invest in the initial cost of a good zoom lens, you needn't bother with a telephoto. Zoom lenses provide further "tricks" not available with fixed focal-length lenses.

The ultimate telephoto lenses are the 500 mm and 1000 mm mirror lenses. Both are light enough to hand hold at 1/1000 sec. and both are incredibly sharp. But because both are very expensive, buy them only if you'll frequently use them.

Do you need a motor drive? Although most pros today use them, your level of photography will tell you when you need this high-priced accessory. A motor drive, for those who don't know, forwards the film after each exposure at speeds up to five frames per second and allows remote control of the camera. I only bought mine after years of waiting until I could make full use of one.

2
The Marvelous Nikonos

You can call it a Nikonos, or a Calypso, or a Nikonos II or III. But don't call it an underwater camera. It's an amphibious camera—and the importance of that designation will become apparent to you only when you discover its multitudinous capabilities.

The Nikonos is Nikon's effort to participate in the booming world of scuba diving and underwater photography. In taking over the old French Calypso camera, Nikon kept its best features and improved on the rest of the camera's outstanding traits.

The end result is a small, compact camera that withstands brutal treatment and almost any environmental extreme. Even a camera's worst enemies—sand and dust—seem to have little harmful effect. I use mine in swamps, in rainstorms, in hurricanes, in swirls of dust, on movie sets, and in place of any other camera I own.

The standard Nikonos lens is a sharp 35 mm focal length with f-stops from $f/2.5$–22. The camera body has shutter speeds from time to 1/500 sec.

Because the camera has no rangefinder, focusing is by educated guess. The lens has an extended depth of field, however, so focus setting is rarely critical. The f-stop and the distance settings are controlled by knobs that extend from each side of the lens. The shutter speed dial is atop the camera.

The shutter release is radically different from most cameras. A lever is pressed toward the photographer and

then released. It springs out and is then depressed a second time, cocking the shutter and forwarding the film one frame. The barely audible shutter click makes the camera excellent for use on movie sets or in hospital operating rooms.

Since its introduction several years ago, the Nikonos has undergone minor changes and has seen the addition of 15 mm, 28 mm, 35 mm, and 85 mm focal lengths. A close-up attachment is also offered. Underwater flash guns are made by Nikon for the camera. A small attachment allows the use of ordinary flash units out of the water. A combination lens hood–filter holder is useful to protect the front lens element from damage.

The camera is so popular and so reasonably priced that there is often a backlog of orders for just the basic camera-lens combination.

You can do anything with a Nikonos that you can do with any other camera. But with the limitation of no rangefinder and the drawback of not being a reflex viewing camera, I would hesitate to recommend it as your only camera. However, it's my first choice as a second camera.

It's also a dandy choice as a vacation camera, especially if you enjoy sailing, skin diving, snowmobiling, or motorcycling. It's a take-it-and-forget-it camera.

Although the Nikonos is amphibious, its primary use is for underwater photography. The remainder of this chapter is addressed to its underwater uses.

Even if you are landlocked, nearby lakes, rivers, and even backyard swimming pools afford ample opportunities for underwater picture taking. The Nikonos will take you down for a swimmer's-eye view of instruction in scuba diving, or swimming classes at a nearby YMCA.

Recently, for example, in order to illustrate a class in swimming instruction for babies six months to two years old, I ordered a 15 mm extreme wide angle from Nikon Professional Services. The 15 mm is one of the sharpest lenses I've ever used, but costs a staggering amount of money. I wanted the photographer to swim very close to the mother and her baby in order to cut down on the clouding effect of any particles in the swimming pool water.

Underwater exposure is tricky, but not impossible without an exposure meter. A basic rule is that in clear water, one f-stop is lost for every three-foot increase in depth. When shooting very near the surface, a surface light reading can be employed. The beginning underwater photographer will

The spearfisherman was photographed in a swimming pool where instruction in skin diving was being conducted. The photographer donned a heavy-weight belt and lay on the bottom of the pool to shoot the figure above him. Data: Nikonos with 35 mm lens, 1/250 sec. at f/8 on Tri-X film. Photo by Dick Dickinson.

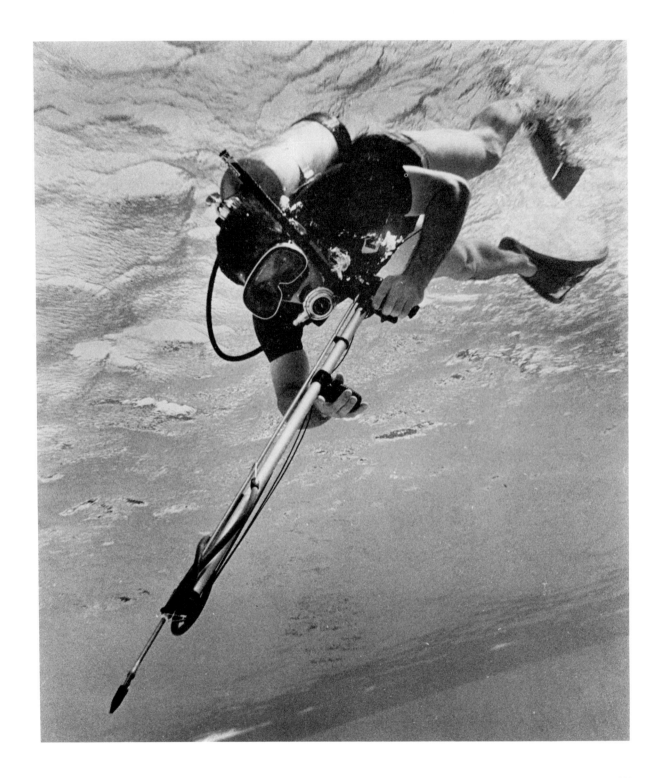

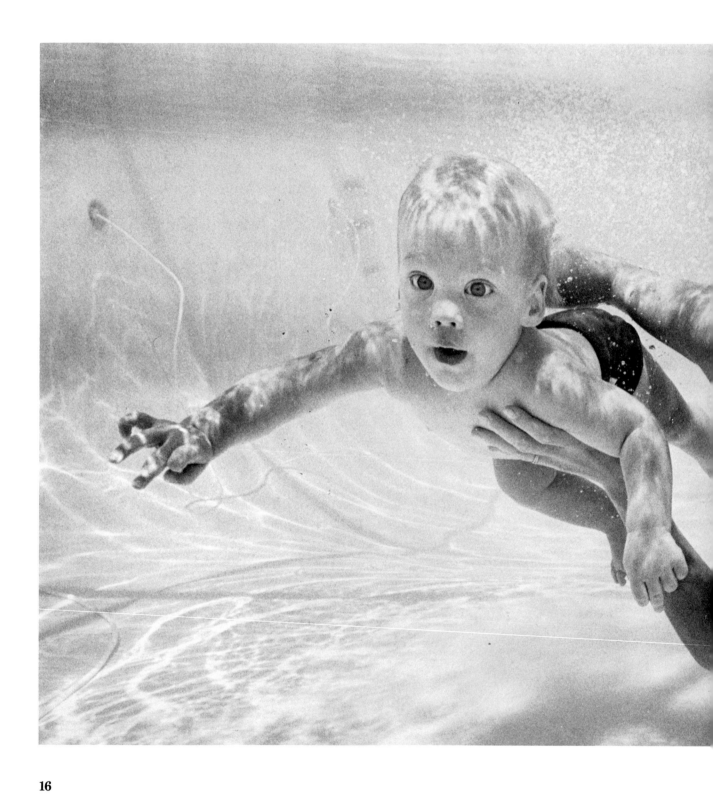

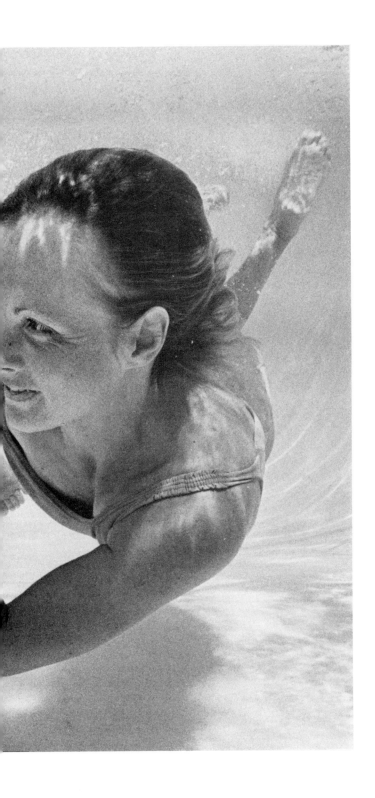

usually overexpose several rolls of film before learning the appropriate exposure to use.

A swimming pool has light-colored walls and bottom that reflect much of the surface light. This effect prevents harsh shadows from blackening a subject photographed from below against a bright surface.

Sometimes this darkening is desirable, however, as I thought it was in a shot of a star high-school swimmer. The photographer donned self-contained air tanks and lay flat on the bottom of a deep pool while the swimmer practiced his laps above.

A scuba diver was also photographed in this same deep swimming pool. Because pools often have clearer water than actual sea locations, they are better and more convenient.

I haven't found it necessary to purchase an underwater flash unit which is costly and uses expensive flashbulbs. The flash units are essential only if you are a deep-diver, and if so, you had better be an expert if you want an exact color rendition of an underwater scene. All of my underwater photography is done on black-and-white film and I'm not an expert diver. If you are, your

This mother and infant were part of a YMCA swimming class for "aquatykes," infants from six months to babies two years old. A 15 mm ultra wide-angle lens made for the amphibious Nikonos camera was used to take this picture on a sunny day in a clear swimming pool. Data: Nikonos with 15 mm lens, 1/500 sec. at f/8 with Tri-X film. Photo by Dick Dickinson.

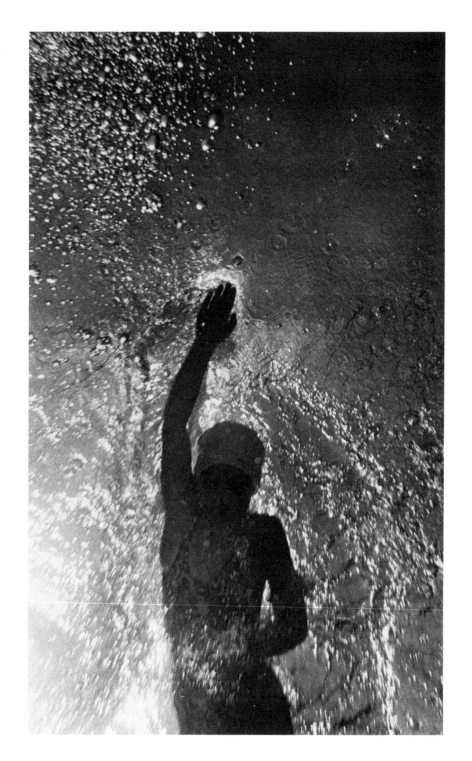

The camera equipment you use must fit your needs and abilities. I have not found an underwater flash unit, which is costly and uses expensive flashbulbs, a necessity.

A high-school swimmer practices laps above a Nikonos camera. The exposure was set to silhouette the swimmer against a darkened sky. The bubbles in the picture are from a scuba tank worn by the photographer. Data: Nikonos with 35 mm lens, 1/500 sec. at f/11 on Tri-X film. Photo by Dick Dickinson.

camera equipment must fit your needs and your talents.

Before closing, I'll prepare you for what is sure to be the typical reaction when you plunge into water with a camera around your neck. It happens every time I take a model to the Gulf of Mexico for glamor pictures.

"Look at the damn fool Yankee," someone shouts.

It's easier to take the slight verbal abuse with a smile on your face than to spend the next half hour extolling the virtues of the Nikonos.

I was going to include a handy, every-occasion exposure chart for underwater photography. Unfortunately, there are simply too many variables to take into consideration. Just a few would include the time of day, the clarity of the water, the position of the waves overhead, the number of microorganisms in the water, the weather, and the cloud patterns. The only hard and fast rule is to "bracket." Select what you think to be the correct exposure and then bracket above and below that *f*-stop. Keep a record of your exposures and lighting conditions and you'll be a pinpoint guesser in no time.

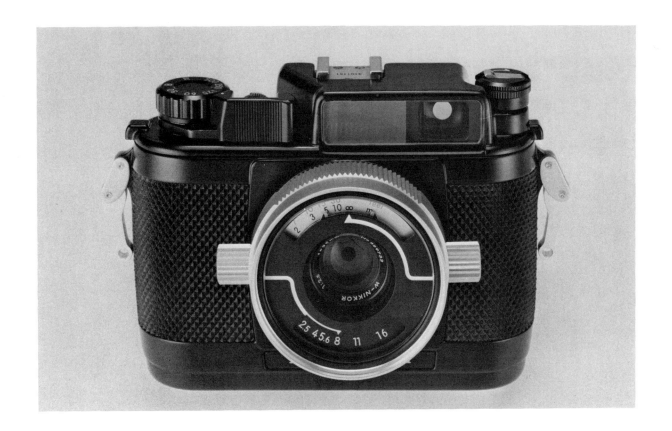

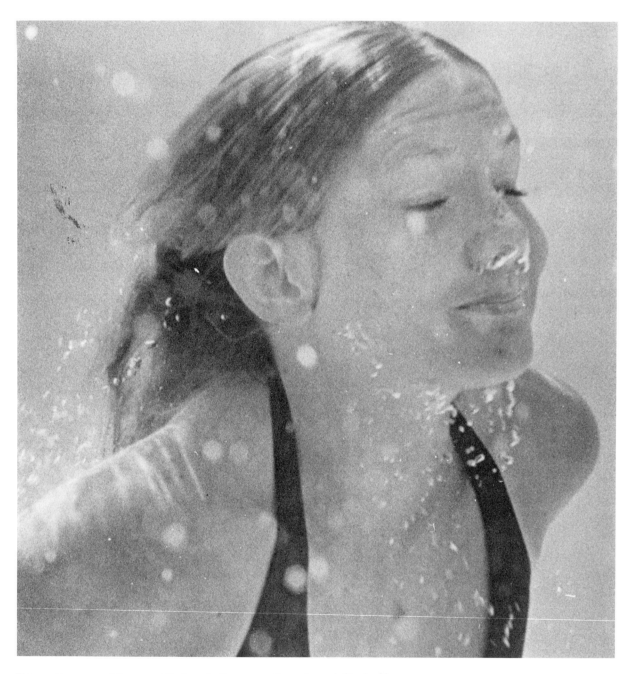

This pretty young girl came a bit closer to the camera than planned. She had been instructed to dive into the pool and pass the camera about two feet away. Instead, she came within about a foot and brushed the photographer over. Data: Nikonos with 35 mm lens, 1/250 sec. at f/11 on Tri-X film.

3

Adding Lenses

When you buy a camera from a photo shop, chances are it comes with what's called a "normal" lens, usually of 50 mm or 55 mm, if the camera is a 35 mm SLR (single-lens reflex).

The 50 mm lens renders perspective in much the same manner as the human eye. But our marvelous eye has what is called peripheral vision—the ability to see a wide view while still concentrating on one object or narrow angle of view.

Camera lenses don't have this feature. The closest we can come to duplicating the human eye is to change lenses. When we want to duplicate peripheral vision, we put on a wide-angle lens. When we want to zero in on a distant object, a telephoto lens helps to concentrate our attention in much the same manner as our eye does.

Let's examine these two types of lenses and see when we should use each. A wide-angle lens is any lens that views a wider angle than a normal lens. Generally, wide angles begin at 35 mm. This lens is a beauty for general photography, and your strobe will still cover all four corners of the lens' view.

A 35 mm lens was one of my first purchases and remains a favorite. You will use it for accident pictures, fires, group shots both indoors and out, sports photos, and many other spot-news assignments.

Next on the list of wide angles is the 28 mm lens, a fairly inexpensive

lens to purchase. This is about the widest lens that can reproduce what appears to be normal perspective. This lens demands some skill in its use, since incorrect tilting will produce distortion.

I owned a 28 mm early and learned to love it. The first time you view a scene through one, you'll feel it is a breathtakingly wide lens. It opens up a new world of photography at close range. The use of a 28 mm lens eliminates the need to back away from a picture. You can work right on top of spot-news events with it, a distinct advantage when competing photographers are present.

The 24 mm lens is a relative newcomer, probably introduced to sell lenses. Nikon's 24 mm has a rear element that moves, or shifts, as you focus at close range. This action is supposed to correct some of the close-focusing faults associated with extreme wide angles.

I prefer the 20 mm. This beautiful lens takes in a breathtaking 90-degree view. It can be used whenever unique perspective is desired. Foreground objects can be made to stand apart from the background while still keeping the background in sharp focus. The 20 mm has a tremendously long depth of field. Almost everything remains sharp, ranging from a few feet to infinity at settings of f/8 or smaller.

The 20 mm is also useful when you find yourself stuck in a horde of photographers competing for front-row position. Once you're there, you'll find you're so close to the subject or action that a 20 mm is essential.

There are three other wide angles I haven't tried. The 18 mm is just another way of selling more lenses. It compares to the 20 mm, but is a lot more expensive.

The 15 mm creates so much distortion with the slightest tilt that it can be dismissed for all but magazine photographers who can afford every lens available.

A nice specialty lens, if you can afford it, is the 16 mm full-frame fisheye. It is strictly a "trick" lens that reproduces 180 degrees across the full length of your negative resulting in a full-frame rather than a circular image.

I don't usually care for circular fisheye images. These lenses carry designations of 12 mm, 8 mm, and 6 mm. Aside from the cheap 12 mm, the others are much too expensive for the average photographer.

There are some new zoom lenses on the market that have a range from moderate wide angle (about 28 mm) to normal or slightly telephoto. Frankly, I haven't had a chance to try one yet, but I would find a zoom with only a 2–1 ratio too restricted in its range. However, if a photographer wanted to be able to cover every focal length with a minimum of lenses, a combination of the wide-angle zoom Nikkor, the 80–200 mm Nikkor, and the 200–600

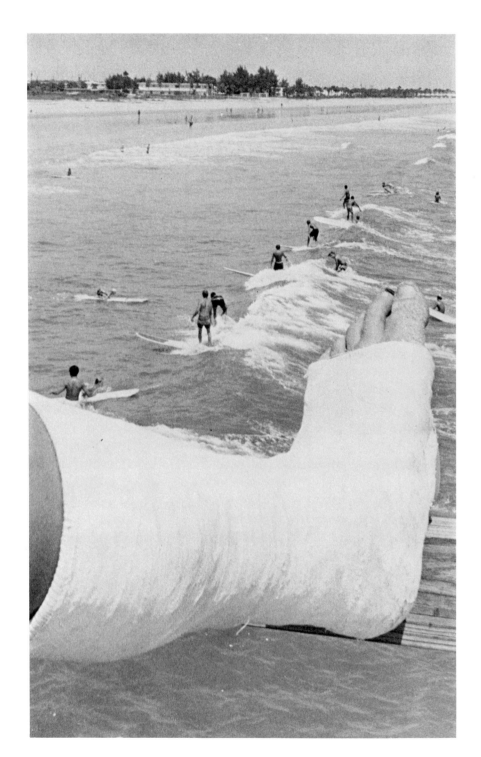

A state championship surfing contest in Cocoa Beach, Florida, turned up this unlucky fellow. He was forced to watch from a pier while his friends competed in the Atlantic waters below. With a wide-angle lens, both foreground and background can be in sharp focus. Data: Nikon F with 28 mm lens, 1/1000 sec. at f/11 on Tri-X film.

mm Nikkor would suffice. With three lenses, it must be remembered, you are carrying a lot of glass—and weight. I prefer single focal-length lenses most of the time, although the 80–200 mm is a fine lens for sports photography.

To summarize, wide-angle lenses are necessary: when you can't back up to increase the area you will cover on your negative; when you want to emphasize a foreground subject but retain background detail; when you want an unusual perspective; and when you are competing with a horde of photographers for front-row position.

The telephoto is another lens you will eventually want to consider owning. Telephoto lenses create their own type of distortion by making objects appear compressed. They take some getting used to, but once you have mastered them, you can make that compression-distortion work for you.

The shortest telephoto is an 85 mm that you should pass up if you have a normal lens. It just doesn't offer enough to warrant spending the money.

You'll probably choose a 105 mm or 135 mm as your first lens. It's difficult to say which is "best." Perhaps your pocketbook will dictate the slower 135 mm, $f/3.5$. Or, if you have the money, you might opt for the new 135 mm $f/2$ lens. I've traded around and swapped from the 135 mm to the 105 mm Nikkor. This classic lens is super sharp, very light and compact, and perfect for portraits.

And portraits are what this focal length is primarily used for. You will use this telephoto only infrequently to pull in distant details of interest. It's not long enough for such purposes most of the time.

The 180 mm is a fantastic but costly lens. It's an $f/2.8$ model, so it works well in low light, particularly for indoor sports. But because it is so expensive, I don't own one. Until the price comes down on a used model, I'll continue to push process my film at higher ASA ratings.

I do have a 200 mm lens which I like to use. It's just right for many sports events such as a rodeo or an auto race. It's also handy for shooting candid close-ups of people at ten feet. At that distance, they are less camera-shy and more apt to be themselves. This lens is particularly suited for shooting children, who may not ham it up so much at that distance.

Both the 135 mm and the 200 mm lenses will allow you to shoot portraits with the background out of focus. Using an $f/5.6$ or wider setting can eliminate a distracting background.

If, however, the background is important and you can't use a wide angle to shoot the picture, you'll want to use a 105 mm or 135 mm at a small f-stop of $f/16$ or $f/22$. Unless the foreground subject is extremely close to you, you will be able to retain both foreground sharpness and some background sharpness at these small f-stops.

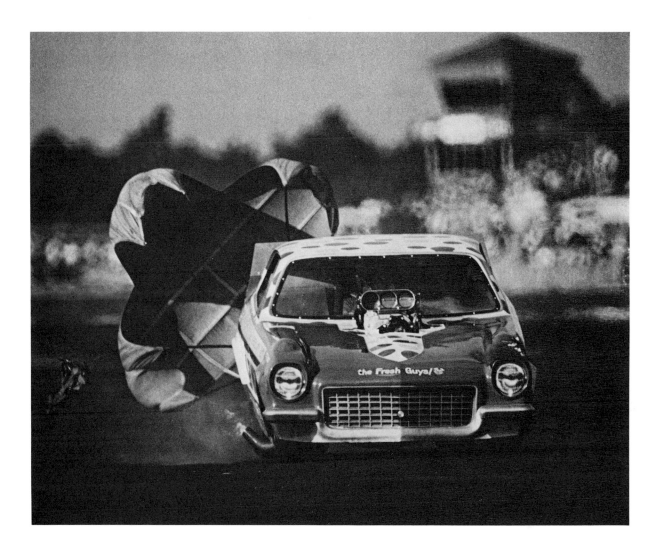

Here's looking at you—from the end of a drag strip as a "funny car" pops a parachute at the end of a 230 mile-an-hour run down the quarter-mile. Special permission was obtained to be in the area and a motor-drive camera was positioned on a tripod before the race. The car had almost completed its six-second run before the sound of the car starting its run reached the photographer. The out-of-focus tower in the upper right is three-quarters of a mile from the photographer. Data: Nikon F with motor drive, 1000 mm mirror Nikkor lens, 1/1000 sec. at f/11 on Tri-X film.

Moving up the telephoto line, we come to the 300 mm lens which I've never liked. The first one I tried was a Nikkor that produced a fuzzy picture at a wide-open aperture. I'd never had that happen with a Nikkor optic and was disappointed.

The 500 mm is a terrific lens. The fact that it has a fixed f-stop (f/8) is limiting, but you soon learn to overcome that shortcoming. It is very sharp, very compact, and light enough to hand hold at 1/500 sec. Since it is moderately expensive, get one only if you need it.

The 500 mm is close-focusing (13 feet) and can shoot full-face portraits at that distance. The background cannot be brought into focus, however. Focusing is always critical with a lens of this length.

Finally, there is a 1000 mm and 2000 mm mirror optic. The 1000 mm is priced so that a few who really want it can afford it. The 2000 mm is priced out of range for all but Mount Palomar.

Obviously, these are specialized optics. Jay Meisel has made a name for himself using 500 and 1000 mm lenses, but most of us will use them very rarely. It's nice to have a 1000 mm on hand in the newspaper pool, however.

I've used the 1000 mm a few times—once from the end of a drag strip to shoot head-on into a car as it popped its parachute, and again on a hijacked airplane. The 1000 mm will put you up close when nothing else will. It has a fixed f/11 stop, though, so it cannot be used to shoot through windows at grand juries. It serves best as an outdoor, nice-day lens.

To summarize, telephoto lenses are necessary: when you can't get closer to the subject, but need close-up details; when you want to eliminate a distracting background; for portrait work; for most sports events; and for compression effects such as stalled traffic or a row of apartment houses.

4

The Sequence Picture

The motor-drive camera has become synonymous with the professional photojournalist who admires it for its remote ability and its "ever ready" capabilities. The motor drive assures the photographer of capturing *the* picture in a situation calling for rapid work. *The* picture might well be part of a sequence. And if the sequence is good enough, five or more pictures may be published to better tell a story.

Sequence cameras are not new, but their useful history goes back less than 25 years. The first sequence camera small enough to be carried by a photographer was the Bell and Howell Foton. Now out of production, the Foton was an expensive and hard to operate spring-drive camera that fired up to six frames a second (depending on spring condition) for 18 to 24 pictures, using 35 mm film.

For several years, I could not afford a sequence camera. I read with envy the inventory of *Life* or *Look* magazine photographers, noting that the Foton was among the equipment they used.

When I finally did save enough to add a sequence camera to my personal stock, I selected a Foton. It had been well used by a newspaper pool that had moved on to even more luxurious equipment.

I bought it for a song and a dance—$100. Searching through local photo shops, I found one that miraculously had a basketful of Foton parts,

27

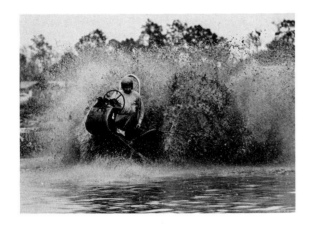

A swamp-buggy racer approaches a deep hole in a spray of mud. This picture reflects a "normal" condition for this type of race (left). The buggy now tilts at an angle that is sharper than normal and appears to be in trouble (right). With the buggy straight up in the air, there is no question that the driver is headed for a mishap—the first in the 24-year history of swamp-buggy racing (left). The buggy flips over backwards and is caught on film a split second before the splashy impact. Fortunately, the driver escaped without injury (right). Data: Nikon F with motor drive, fired singly, 80–200 mm zoom lens, 1/1000 sec. at f/8 on Tri-X film.

including springs. Some guy had tried to take apart and repair his Foton, had brought it to the photo dealer in a box, and found to his chagrin that diagrams for camera repair were either nonexistent or impossible to find. So he sold it as parts, along with a 100 mm lens, which naturally, I bought right away.

I found the spring would drive the film at only about four frames per second, but the camera served me well for two baseball seasons. The 100 mm lens was long enough to cover first or third bases from the fences, but I was frustrated at covering second.

There were other drawbacks that dated the camera. It was a rangefinder and I much preferred single-lens reflex cameras. The focusing was accomplished by turning a knurled ring that was guaranteed to tear the skin from your finger. And the final drawback

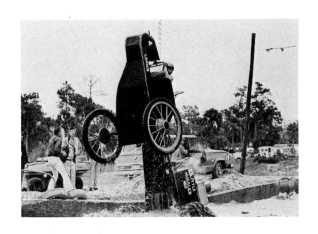

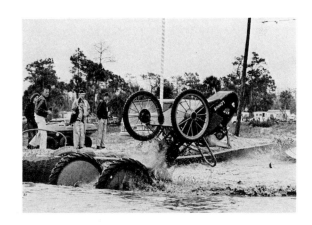

was that the camera wouldn't trip remotely—the cable release socket was busted.

I finally sold it for a song and a dance—$150—to a collector who turned positively green at getting it. And I bought the Nikon motor drive which has served me well for about eight years. As we next examine two sequences made from sports events, you will learn how to increase your chances of capturing a sequence for display in your paper.

Each year in Naples, Florida, a mad event called Swamp Buggy Racing takes place. Swamp buggy racing began in 1949 as a friendly contest among men who built the ungainly monsters to penetrate the Everglades swamp on hunting expeditions.

Since that time, the sport has grown to the point that the swamp

buggies use dragster engines, waterproofed of course, connected to automatic transmissions. They reach speeds of 30 miles per hour through the mud and water mixture and throw rooster tails 100 feet behind them and 40 feet in either direction to the side.

Until 1973 there had never been an accident during a swamp buggy race. But the course is studded with deep potholes in which the smaller buggies are practically submerged. Since I had been to the races several years in a row, I staked out a position at the first pothole—the deepest on the course.

I prefocused an 80–200 mm zoom lens on the pothole and waited for the first buggy to come through on a return run around the track. Lonnie Chesser, a perpetual winner, was the driver of that buggy. I snapped off a picture as he approached the pothole, then clicked a second time as he nosed through it.

But wait! The buggy didn't continue out, but rather tilted skyward. Click! Suddenly it was going over backwards, and I clicked again. During this time, I had zoomed from 200 mm back to 80 mm for the straight-up shot, then to 135 mm for the flip backwards. My reflexes missed the splashy impact. (I prefer to shoot one frame at a time to retain total control of what I'm getting, rather than simply running the motor and eating up film with a chance of missing the critical moment.) The final shot I needed was the rescue—I waited until Chesser emerged to shoot.

This sequence could have been made by a good photographer without a motor-drive camera. But the motor drive kept the camera ready every time I pressed the shutter release. Nothing is so distracting to sequence photography as having to remove your eye from the viewfinder each time you have to wind the film. That's where the motor drive performs one of its finest functions. It winds for you while you keep your eye on the scene you are photographing.

At another sports event—this time a go-cart race—a spectacular wreck took place directly in front of me. When I arrived at the road race, I walked the track and observed skid marks made by the go-carts during practice. One turn looked particularly tricky.

I put a 135 mm lens on the motor drive, focused on the hay bales lining the course, and waited. Again, it didn't take long. A cart driven by a Miami man came through the turn at about 60 miles an hour, drifted in a four-wheel skid to the outside, and seemed headed for the hay.

I braced for impact. Click! The go-cart flipped! Go-carts have such low centers of gravity that they almost never overturn, yet this one did. I clicked again when the cart was in mid-air. And again as the driver came down hard on his back. Then I held the motor in the open position, taking three pictures per second. I follow-focused and watched the driver tumble

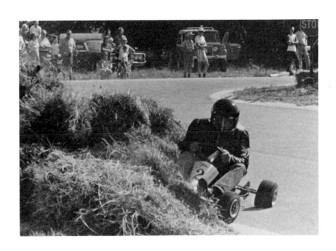

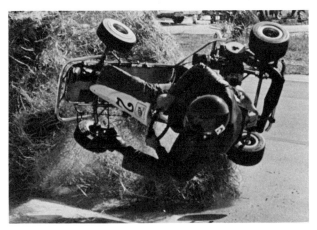

A go cart racer skids out of control and smashes into hay bales lining the Venice, Florida, course (top). Incredibly, the cart flips, taking hay with it (center). The driver lands heavily on his back at 60 miles an hour (bottom). The cart and driver continued tumbling down the street, along separate paths, but further pictures were not nearly as dramatic as these three. The driver was not seriously injured. Data: Nikon F with motor drive, fired singly, 135 mm lens, 1/1000 sec. at f/8 on Tri-X film.

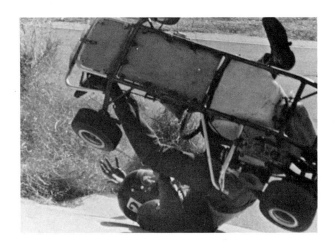

twice as the go-cart cartwheeled down the track.

After it was over, I learned another photographer next to me had dropped his camera and run, fearing the cart might strike him. I had the only pictures.

A newspaper editor hates to hear a photographer report that there was a spectacular accident, but that he or she happened to be in the wrong place at the wrong time, and consequently missed the best photos. I love it when my sequence pictures run seven columns wide on page one as the other photographer explains his dilemma to his boss.

The beauty of the sequence camera is that it eliminates having to explain or make excuses to your boss as it increases your chance of getting the picture.

5

The Frozen Blur

The photo assignment was to photograph Miss Florida as she practiced her talent routine for the Miss America Pageant. Perhaps the picture would have been less interesting had Ellen Meade been a singer, or a piano player, or even a ventriloquist. But no, she was a roller skater—one of the best in the nation. And she hoped to reach the finals to present her talent and to try to popularize roller skating as an Olympic event.

The standard shot would have been of a static beauty on roller skates. But to Ellen Meade, roller skating was grace and beauty in motion. I had to make some attempt to portray those traits in the final picture.

There are several ways to picture action—but in the end the picture is either frozen, blurred, or a combination of both. The latter is the least often used technique, the most difficult to achieve, and the one I chose.

A static shot is good only when the peak of action is obvious. It may be a good choice for a high jumper, pole vaulter, or sprinter at the finish line, but it wouldn't work for a roller skater.

Blur action is fine for cars, motorcycles, or bike racers. It is not so good when a person's face is needed in sharp rendition.

So I came to solution number three. I conceived a picture of Ellen Meade emerging from a blur into a frozen image. This would involve finding the right technique and equipment.

The excellent *Time-Life* series on photography provided the technical solution in its edition entitled *Special Problems*. The example used in the book to portray this technique was of an airplane taking off. The photographer had used a camera with a leaf shutter and the text noted that this shutter closes more slowly than a focal-plane shutter (the type on the motor-drive camera I would be using).

To achieve the combined-action effect, two light sources are needed: a floodlight and a strobe or electronic flash unit. If the floodlight can be controlled in its intensity by a rheostat, as was mine, all the better. The flood provides the light to record the moving skater as a blur, while the strobe provides the final frozen image.

Also essential to the picture was a device with the rather complex name of a "double-pole, double-throw, center-off switch." When I need electronic devices of almost any kind, but particularly switching devices, I head for Radio Shack. If I recall correctly, this switch was about $1 (two to the package).

Two household cords are attached to the switch. One cord with two leads is attached to the right side of the switch and will connect with the camera. A second cord with two leads attaches to the left side of the switch and trails off to the strobe.

A motor-drive camera or a solenoid switching device is needed for this picture. The double-pole, double-throw switch will control the solenoid or motor drive. Household plug tips on the cords are inserted into the motor-drive camera and into the strobe. When the switch is thrown one direction, the camera turns off . . . but, the strobe fires a split second before the shutter curtain can close, thus recording the final frozen image.

I showed up at Miss Florida's house quite early in the evening and supervised her costuming and making up. Since a black background is needed to show the blur, I waited until after sunset to begin shooting. And since contrast is needed between the subject and the background, I chose a light yellow skating outfit with long sleeves, and white skating shoes. Her makeup had to be more contrasty than normal, in consideration of the black-and-white film I was using.

While she was getting prepared, I began laying electrical cord from the house to a concrete patio her father had constructed in the backyard. I positioned the strobe to light her almost head-on from a high angle, with the floodlight lighting her from the left side but also near head-on.

The floodlight was turned on and exposure reading begun. I anticipated an $f/8$ setting and worked to achieve it. She would travel about 10 feet as a blur in about one second so I dialed the rheostat control to give a reading of 1/10 sec. at $f/8$. The strobe was set at a distance that metered $f/8$. (I use a Gos-

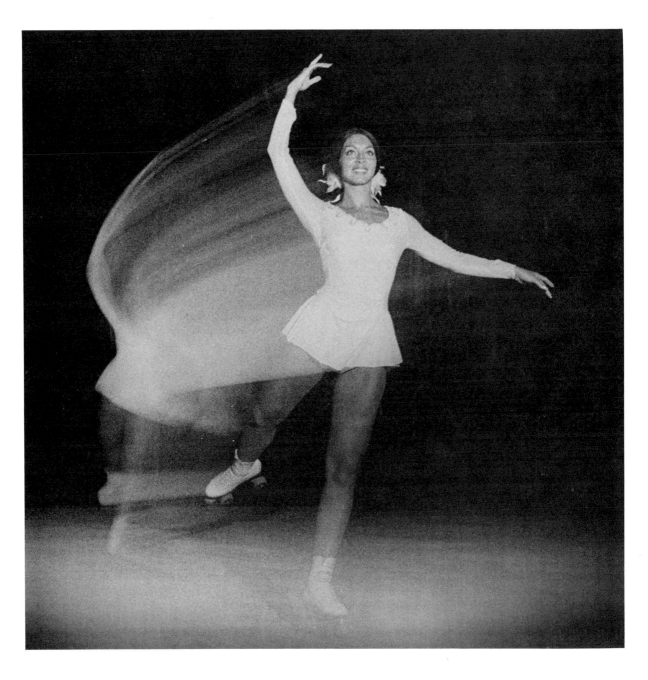

From a graceful blur on the left, a former Miss Florida emerges into a sharply frozen image on the right in a technique requiring a time exposure and a strobe burst. Data: Nikon F motor drive, 35 mm lens, one second at $f/8$ with both floodlighting and strobe used in connection with a special switch.

sen exposure meter for flood and available-light work, a Wein strobe meter for electronic-flash work.)

Miss Florida came out of the house, looking beautiful, and had thoughtfully added two colored ribbons to set off her black hair. I shot only three pictures. I asked that she raise one arm and extend the other. The angle of approach, which was initially straight across the film, was changed to a more head-on attack. And bingo, number three was a beauty.

For each shot, I shouted constant directions. I had an assistant hold a hand over the camera lens when the switch was first thrown (to prevent any unwanted streaks as the motor opened the focal-plane shutter). Then I called out for Ellen to begin to skate toward me, ordered the hand off the camera as she reached a distance about 15 feet away, followed her as she approached, and threw the switch to fire the strobe when she was about 5 feet in front of me.

The distances were measured before shooting began by observing her on the ground glass. Since the camera must be set for time exposure, no observation of the subject is possible on the ground glass during the actual exposure. (The mirror flips up on my camera and blacks out the image.)

The final exposure data was: Nikon F motor drive, 35 mm lens, Tri-X film, time exposure for about one second at $f/8$ with electronic flash.

The picture that resulted was three-quarters of a page in size. It was used in the Miss Florida Pageant program, and is currently being used in Miss Meade's advertising of her dancing-skating school.

6

Panning and Trucking

I have written about two methods of portraying action in still photographs. I showed you frozen images, in sequence, made at the peak of an action. And I featured a blur-frozen combination that combines a totally blurred image with a frozen one.

Now let's consider another method of picturing action: the pan shot.

First, I must concede that any attempt to picture "action" in a still photograph is illusionary. We must be magicians; we must use tricks of the cartoonist to convince a viewer that what is obviously still in the picture being viewed is really a subject in motion. In effect, we are creating a visual lie.

As a still photographer, your illusionary image is considerably more complicated to produce than that of a movie maker, who has motion, sound, color, and even 3-D to work with. You, alas, have only a flat black-and-white print. But, given the confines of our work, we can still picture action that appears so violent the print seems to shake.

The pan shot is an extremely useful photo-trickery technique which should be learned well. You can recognize a pan shot by the blur present. Usually the background is blurred beyond recognition while the subject in motion is only slightly blurred.

There is great disagreement among photographers as to what degree of blur is acceptable in the subject.

You and your editor must decide this on a subject-by-subject basis.

Personally, I dislike any blur shot in which the subject of the picture is not immediately evident. That means, for example, I don't like those shots of dancers pictured as blobs of white against a black background. I feel that in the newspaper business, a picture exists to serve a viewer. Complex, hard-to-read pictures have no more place in your newspaper than complex, hard-to-read stories.

Now let's consider the technique of acceptable pan photography. The word "pan" is a movie term. Panning means following a moving subject while using a relatively slow shutter speed. How slow depends on the subject. Your only hope is to bracket exposures, using the highest (smallest) f-stop you have (f/22 or f/32) and the slowest shutter speed compatible with the available light.

Another rule is to use the longest lens, usually a 135 mm or longer, you can direct on the subject. The longer the lens, the greater the background blur will become and the easier it will be to follow the moving subject.

Of course, there are exceptions to this procedure. The finest picture I've ever seen of auto racing was done by Horst Baumann, who used an extreme wide-angle lens to capture the late Jimmy Clark cornering a Lotus grand prix car at 120 miles per hour. Baumann was within three feet of Clark's car and panned with the car.

The picture was distorted by the focal-plane shutter movement, and it appeared the car was bending as it traveled through the turn. Baumann took a risk and was very, very lucky to get the picture he did because normally, wide-angle pans are unsatisfactory.

Begin by putting a 135 mm, 200 mm, or longer lens on your camera and hunting a subject that will travel, in either direction, across your field of view. Set your exposure for 1/60 sec. or slower shutter speed and then follow the action as the subject moves. When the subject is centered in the frame and directly in front of your camera position, squeeze the shutter release and continue to squeeze while following the action.

Your first attempts may fail because the tendency is to stop following the subject at the moment of exposure, and to fail to follow through after the exposure. If you do that your subject becomes hopelessly blurred and you might as well have waited for the subject to reach that area in your frame. You have not taken a pan picture.

It takes concentrated effort to "unlearn" years of training that required steadying the camera at the moment of exposure. But the camera must be in motion, in "synch" with the subject, as you expose a pan subject.

It is best to try a variety of exposure combinations on the same subject. Some combinations will produce too much blur, despite your best efforts at

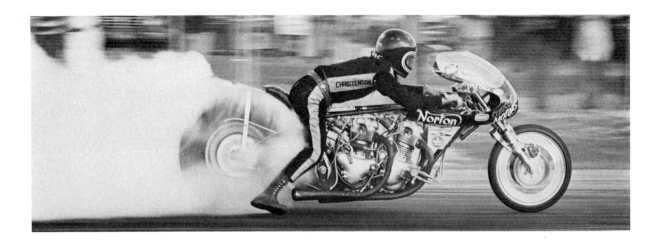

A twin-engine motorcycle drag racer burns his rear tire before a race and is captured by the photographer as a sharp image against a blurred background (above). The day was bright and sunny, and, with Tri-X film, a fairly fast shutter speed had to be used. But the motorcycle moved so rapidly that panning still produced pronounced blur. Data: Nikon F with motor drive, 105 mm lens, 1/125 sec. at f/22 on Tri-X film. Photo by Dick Dickinson. Nighttime at a county fair provides the opportunity for this picture (below). The photographer, riding on the same ride as these girls, photographed them as he faced backwards. Data: Nikon F, 50 mm lens, 1/8 sec. at f/5.6 on Tri-X film. Photo by Dick Dickinson.

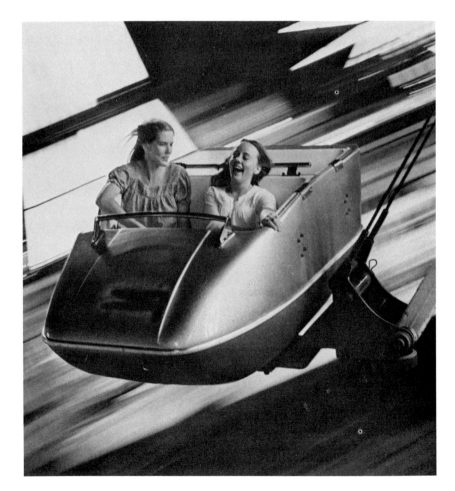

following the subject. Others will have too little background blur.

Tri-X film, the standard, is too "fast" for pan pictures. If the day is sunny and clear, the basic Tri-X exposure at f/22 is 1/250 sec., which is not a slow enough shutter speed. Changing film to either Plus-X or Panatomic-X will allow 1/60th sec. and slower shut-ter speeds on sunny days. If your action is indoor, you can stick with Tri-X.

Pan shots work best on mechanical, non-human subjects. But unusual pictures can be obtained of sprinters, horses, and the like. The problem is that different parts of humans and horses move at different speeds. Both the swinging arms of a sprinter and his

This go-cart was traveling about 90 miles an hour when the shutter was snapped. Notice the focal-plane shutter rendered different shapes for the front and rear wheels, indicating the panning was not constant. Data: Nikkorex F, 135 mm lens, 1/60 sec. at f/11 on Panatomic-X film.

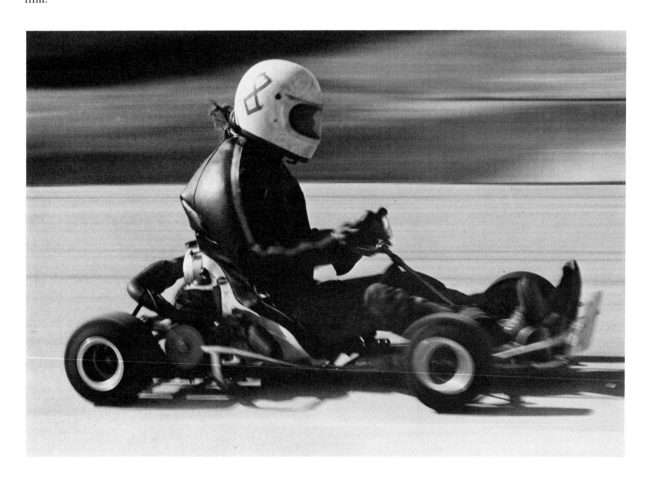

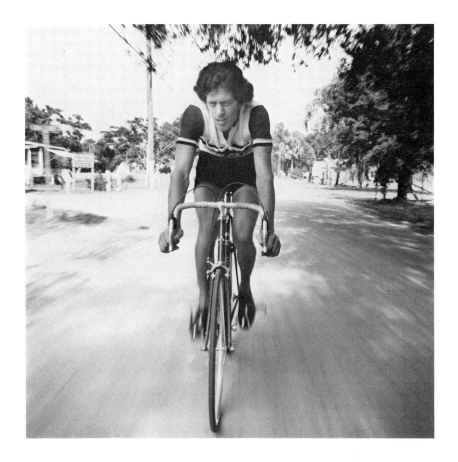

Where was the photographer when this trucking shot was made? He was riding in the open trunk of an automobile moving ahead of the bicycle and at the same speed. An extreme wide-angle lens was used to pull in the trees on each side and a slower-than-normal shutter speed rendered them as soft blurs. Data: Nikon F, 20 mm lens, 1/15 sec. at f/22 on Panatomic-X film. Photo by Dick Dickinson.

legs may be hopelessly blurred in a pan shot. In a shot of a running horse, the horse's legs will also be blurred in the same way.

The choice of shots will depend on the taste of you and your editor. One of the all-time great pictures from Olympic competition was a pan shot of Wilma Rudolph crossing the finish line. But this picture contained very little blur.

There is another type of pan shot that movie makers call a "truck." To "truck" is to move at the same speed as the subject, parallel to the subject. Thus, if you are in a race car running side by side with another race car, you can take a picture which will show the other car frozen against a blurred background. This technique is used most often in "set up" pictures.

A variation of the truck shot is obtained when the photographer is a part of the moving subject or the camera is mounted on the moving subject. This can be done at county fairs, for in-

stance, where the photographer can be on a ride, shooting backward at another part of the ride. Since the photographer is moving at the same speed as the subject, the subject will be nearly frozen, while the background is blurred.

One final variation of the blurred-background, frozen-subject picture involves using a wide-angle lens while trucking in front of the subject. In a story on a bicycle racer, we used both a parallel truck shot and a front truck shot.

To introduce the illusion of motion in a head-on truck shot, there must be objects on each side of the moving subject that will blur during exposure. The faster the subject is moving, the easier it becomes to blur side objects. The effect is very similar to that of a moving zoom shot.

To shoot the bike rider, the photographer rode in the back of an automobile, in an open trunk. The bike rider rode behind the car and both car and bike then moved down a road with trees hugging both edges of the pavement. The trees blurred during the slow exposure, while the bike rider remained apparently stationary in the center of the frame.

If there is a rule concerning pan photography, it is the same rule applied to all types of experimental work: bracket exposures. Then keep notes of those exposures. You should soon be able to watch a racer move down a stretch of road and know that you need only a 1/125 sec. shutter speed for exactly the right amount of blur.

Don't be discouraged if your first efforts don't pan out, or an editor pans your work. Just keep on "truckin'."

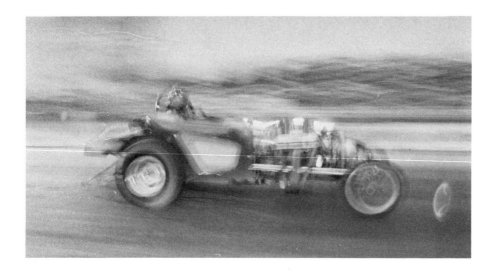

This is about as much blur as is acceptable to most persons. The occasion was a night drag race and the lighting was extremely poor. The photographer hand held the camera in front of him and sighted the racer by looking over the prism point at the driver's helmet while panning at arm's length. Data: Nikon F, 20 mm lens, 1/4 sec. at *f*/4 on Tri-X film.

7

Accident Considerations

Let's talk about accidents. Not the kind that ruin your film, but the kind that are most frequently photographed on our highways—automobile accidents.

They dominate the "disaster" coverage of most small and medium-sized daily and weekly newspapers. And well they should, since they snuff out 55,000 lives every year and put local names into print more often than anyone would like.

Newspapers are not interested in accident coverage just "because it sells newspapers." Sales remain steady with or without sensational headlines or pictures. We cover accidents hoping that through our coverage at least some of our readers will slow down and live. As with much of the news, we hope our coverage of automobile accidents teaches and alerts our readers. With that as our reason, we can now consider what type of accident picture is most effective in the teaching or deterring process.

A photograph of gore is not to my taste. As a matter of policy, I attempt to exclude any picture that shows an uncovered body. Other newspapers may differ and strong arguments can be made for their side. It is largely a matter of preference as to how stark accident pictures will be.

There are some useful rules to follow regarding accident pictures. The first rule, as with all good pictures, should be that the accident picture

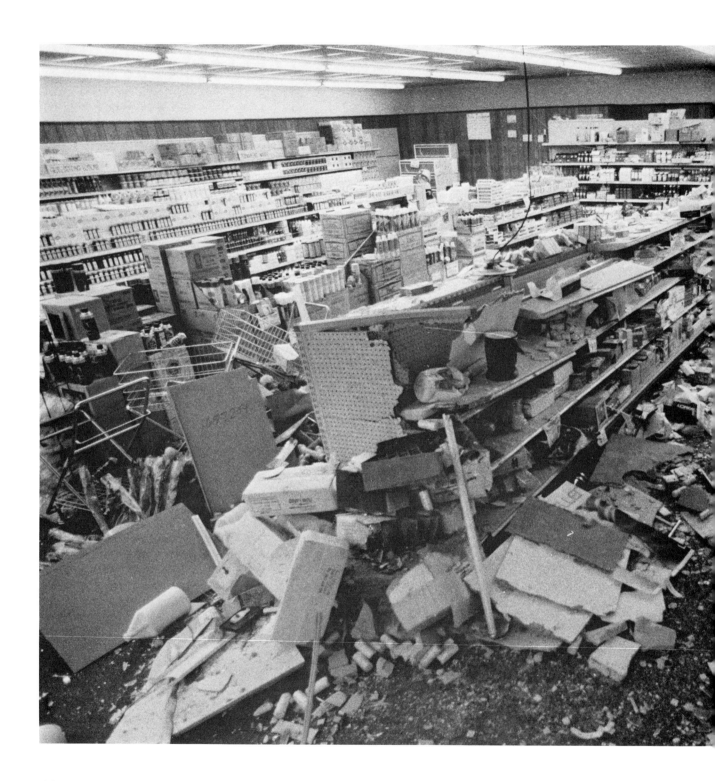

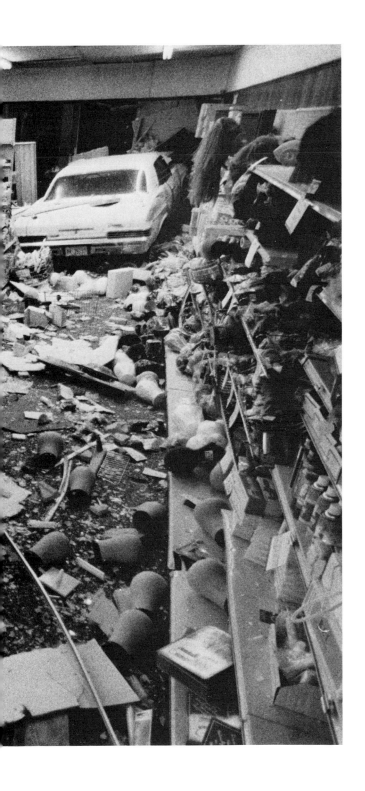

clearly tell the story. Most often this story must be told in one photograph.

In order to show all the important details in one picture, accident pictures should be overall shots. (One photographer once said he could illustrate an entire war with one close-up and one overall. The same is true of almost any news event.)

Notice all important details in deciding what to picture. If three persons died in one car and no one was injured in the other car, then attention can be quite rightly narrowed to the death vehicle.

I'll assume daylight accident pictures pose no exposure problems for you. They rarely do, unless a rainstorm is in progress just as you want to take the picture. But accidents at night present a number of problems that call for heightened knowledge of lighting techniques.

Zero in tightly on your subject. Although skid marks may be extremely important to police investigators, they hold no particular importance to news photographers. If a background sign will clearly locate an accident scene, use it. If a rain-slick highway caused the wreck, show the glistening road. If the car was struck by a train which is

This car chose 4 A.M. to smash into a beauty shop. Overhead lights were on from the middle of the store to the rear. Strobe was bounced off the ceiling at the front of the store to even out the lighting and an extreme wide-angle lens was used to provide great depth of field. Data: Nikon F with motor drive, 20 mm lens, 1/60 sec. at f/5.6 on Tri-X film.

45

out of view, show the tracks or the crossing sign. Perhaps a car ran a stop sign. If so, show the sign in the foreground with the wreck behind and to one side. Above all, try to tell the story in one picture.

Most night accidents can be photographed in straightforward fashion, with one strobe attached to the side or top of your camera. One flash will usually light an area sufficiently large to show two cars. But if you want details beyond about 25 feet you'll have to turn to other techniques.

When I was a newcomer to photography more than ten years ago, I was sent to an accident where a car had driven through a set of barricades, through a huge trench dug for a sewer line repair, through a six-foot tall mound of dirt removed from the trench, through a second set of barricades, and had come to rest some distance down the road.

Both the car and each fragment of the total scene showed little damage. To best portray the accident, I needed one overall shot that would show the full extent of the car's rampage.

Frankly, I stood bewildered until a veteran photographer (fortunately from our newspaper) came by. He stopped, came over, scratched his chin a moment, and walked back to his car. Out came a tripod, a camera, and one strobe. There is no way, I thought at the time, that one strobe will light up this place.

He screwed the camera onto the tripod, focused it, moved about, focused some more, and then dialed his f-stop. He twisted a cable release into the shutter release, pushed a plunger and tightened the release down. Then he held the strobe high over his head, pressed a button and it flashed.

He then walked forward and to one side of the first barricades. Flash. He walked still further, to the trench. Flash again. He walked to the mound. Flash. To the car. Flash. And then he calmly returned to his camera, released the cable release, unscrewed the camera from the tripod, and packed up his gear.

This particular veteran gave out no secrets; perhaps you've met one like him. He kept a little black book into which each complex exposure was logged. The book was always in a pocket of his rumpled coat.

But there were other talkative veterans at the paper who told of the "open-flash, painting-with-light" technique. The idea is to use one flash as if it were several, setting it off to cover only one part of the picture each time. A camera set for time exposure records

In accident pictures, try to include elements of the scene that relate a message of safety for other drivers and your readers. The sign and the railroad track in the top photo are important story-telling elements. Data: Nikon F, 55 mm lens, 1/250 sec. at f/11 on Tri-X film. To take this picture of a tanker full of gasoline rolled over onto a car containing several persons, three strobes were used. Two, fired remotely by slave attachments, were triggered by a strobe on the camera. Data: Nikon F, 35 mm lens, 1/60 sec. at f/5.6 on Tri-X film.

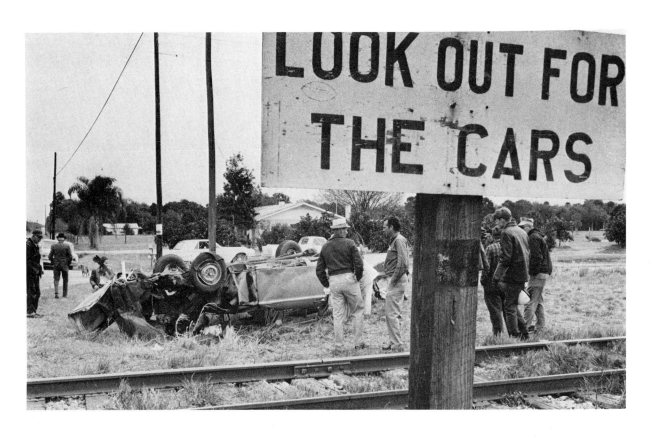

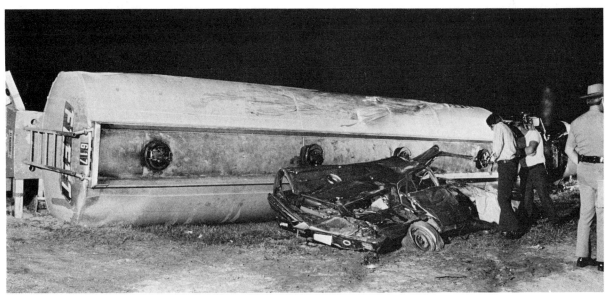

47

each flash until the entire area is "painted" with light. Then the photographer closes the shutter.

I've used the technique many times since to light not only large accident scenes, but also a church at night, a new civic auditorium viewed from outside at night, and even some large and dark interiors.

The technique works only if available light doesn't build up and create a dense negative. It obviously works fine in pitch black night scenes. Remember to stay outside of the picture yourself when setting off the flashes or you will appear in the picture as an outline and your flash will appear as a point source of light.

When a tanker full of gasoline rolled over a station wagon filled with people, the result was a horrible accident involving multiple deaths. The tanker was very long and the scene could not be properly lighted with one strobe.

I carry three. Two of the three are equipped with Wein slave units. These are small units the size of sewing thread spools that contain electronic circuitry that triggers a strobe when another strobe is fired. Each slave plugs into one strobe and each strobe is attached to a lightweight light stand.

The scene before me was swarming with people. The open-flash, painting-with-light technique won't work well if a large crowd is present. People may move in or out of the picture. So I opted for multiple lights on this scene.

I walked quickly around the scene and selected a vantage point from which I hoped to shoot. I then located one of the strobe lights with slave at the far end of the tanker, to light about half of the huge vehicle. The second strobe with slave was placed about one third of the distance from the front of the tanker, to light the side of the crushed car and the front half of the tanker.

The final strobe, as always, was attached to my camera. Each time the camera strobe fired, it automatically fired the other two strobes.

The only problem I encountered was that each time any other photographer from two competing newspapers flashed his strobe, my strobes went off also. Since strobes recycle almost instantaneously, I didn't mind "loaning" my lights. But I did provide the competition with pictures that were well lighted.

The slave units on strobes will fire up to 150 feet from the camera light source. Two in a row can cover almost 450 feet. Since the tanker wreck, I've made a radio-controlled strobe that is fired by my camera's synch mechanism and controls light up to one-quarter mile away.

I have come to a definite conclusion—good accident pictures are no accident.

Photographing Fires

Next to automobile accidents, fires probably constitute the bulk of your local spot-news coverage. Dramatic pictures often receive large display and become a showcase for the individual photographer.

Daytime and nighttime fires require two entirely different photographic techniques, both of which I'll explain. As with all topics, it helps if the photographer knows something about the subject being photographed. But let's quickly admit that pictures of fires must be made on a reflex basis. You see the action, then photograph it. No fire follows a predetermined plan—each is unique.

With some knowledge of the job of a fireman, the photographer will be able to concentrate on the firemen who are fighting the most dangerous part of the fire. Under a good chief, the best men are usually in this location.

The biggest problem with daytime fires is contrasting the flames against the background. Try to place flames against a background of dark smoke. Using the same color filter as the subject will lighten the subject. Depending on the color of the flames, a red, orange, or yellow filter may help. Use of a filter of a complementary color will darken the subject. A blue filter, for example, will create very dark flames.

I've found filters for black-and-white film particularly helpful in bringing out flames of forest fires. Decide which contrast will best apply to

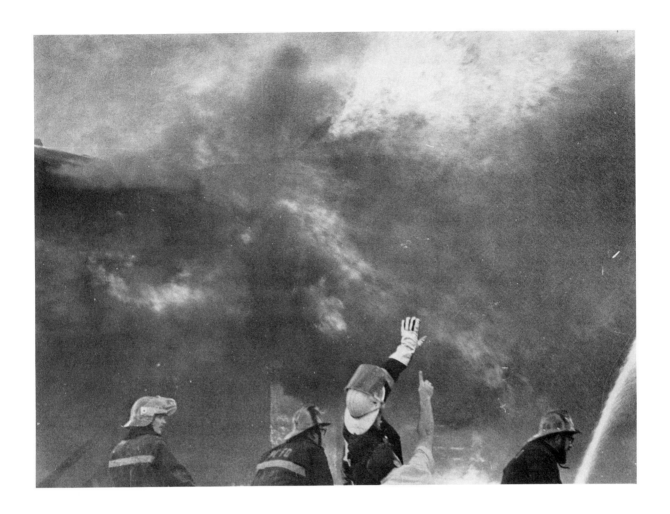

Flames roar above a group of five firemen. Two of them are concerned with what's going on above them, as parts of the burning building begin to collapse (above). Data: Nikon F, 135 mm lens, 1/1000 sec. at f/8 on Tri-X film. A lone fireman walks in front of a burning lumberyard store at the height of the fire (right). This picture was made after the photographer ducked out from behind a stack of lumber and then ducked back again. The heat was so intense it was almost impossible to face the burning building more than a few seconds at a time. Data: Nikon F, 20 mm lens, 1/1000 sec. at f/8 on Tri-X film.

the background you have. Use of a red filter will create white flames against a background of dark foliage. A blue filter will darken the flames while lightening the foliage and sky.

Filters also help protect the front glass element of your lens. This is no small consideration when photographing fires. Water, soot, and debris often strike the lens. It is far better to lose a filter than a lens.

I ruined a filter once when sparks from a welding operation bounced off it while I was exposing the streaks at 1/30 sec. The sparks severely pitted the glass filter. If the filter had not been there, it could have been the lens.

This same dramatic effect of streaking sparks can be created when firemen cut into a wrecked car at night to free trapped victims. Use a strobe and a very slow shutter speed, say 1/15

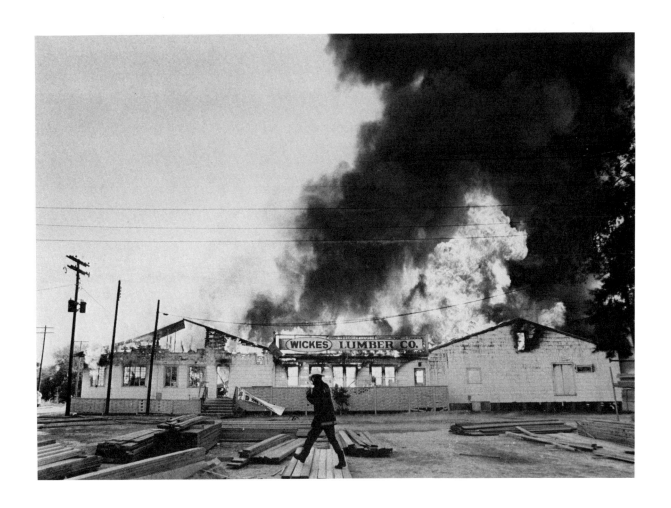

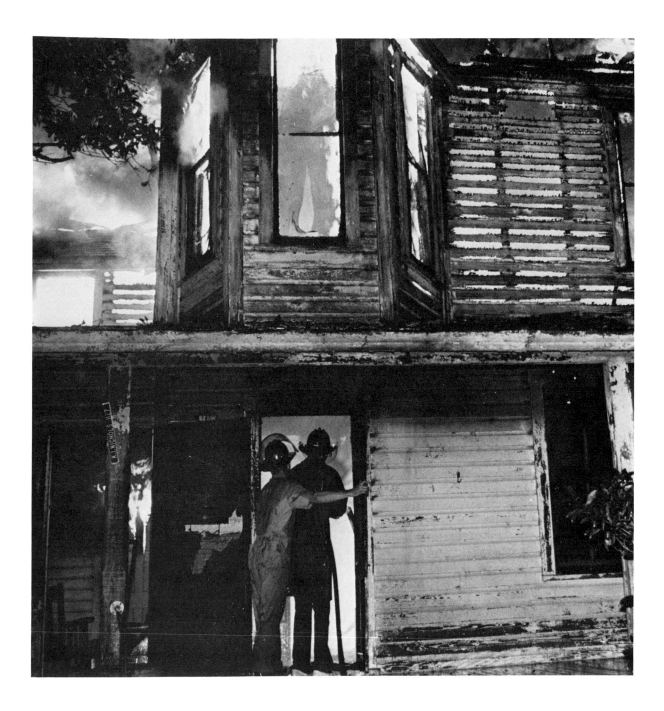

This picture illustrates a strobe picture, used by the *St. Petersburg Times*. Data: Nikon F, 35 mm lens, 1/60 sec. at *f*/5.6 for both pictures, one with and one without strobe fill-in.

sec. The strobe flash freezes everything, but the slow shutter speed allows the sparks from the cutting equipment to trace burning streaks across the scene.

To obtain an even better picture of a daytime fire, it helps if every scene has firemen featured in the foreground; unless the fire is a very large one, demanding an overall taken some distance away. At the height of the fire, you should concentrate on the action of fighting the flames. But don't stop when the fire is nearly extinguished. At this time, the firemen are exhausted and some dramatic portraits can be made.

Finally, when a rescue is involved, that should occupy your full attention. People are far more important than property.

Caution is of the utmost importance. Beware of power lines that can kill firemen and photographers. Often the lines above your head and on the ground are "hot." If they fall or if you step on them, you are dead. If they fall in water and you're standing in it, you are dead. Be extremely careful.

Also watch out for boards with nails in them. So far I've stepped on two such boards in ten years of fire photography. The end result is always a trip to the emergency room for the inevitable tetanus shot.

Should you be allowed inside a burning structure with firemen, be extra cautious. Follow them closely. Try to be very alert and listen for sounds that warn that the ceiling or floor above you may be giving way. Be sure that the floor you are standing on is still solid.

Try to stay out of smoke—period. The smoke could be toxic and without warning you could simply drop where you are standing. Toxic smoke was a by-product of a recent fire I covered involving insecticides.

Follow every instruction from the fire chief. There are trucks on almost every highway now carrying highly dangerous chemicals—explosives, corrosives, combustibles, those with hot temperatures, toxic gas. If the chief warns you to back away from the scene, do so. Work instead with a telephoto lens from a safe distance. No one is paying you to die.

Night fires are easier to photograph because there is no problem with contrasting the flames. They leap skyward against the black night and almost guarantee dramatic pictures if the exposure is correct.

Standardize your film and your developer so you will have a constant formula to work with. I use Tri-X film and D-76 developer for 95 percent of my work.

I usually photograph the flames of night fires at 1/60 sec. at $f/5.6$ or $f/4$. This allows me to use a strobe for necessary fill-in light. Flames vary in intensity and chances are almost any exposure you choose will register some

flame, but exposure of 1/60 sec. at f/5.6 is my choice from experience.

Since most firemen dress in black, your placement of them within the picture becomes more important at night fires than at day fires. Try to register them against the bright flames.

Even with a strobe, the darkly dressed firemen just won't come out well against the night sky or a blackened house. Search for a position where the firemen are surrounded by flames. Then take the picture using a strobe to partially light them.

If your night fire is a particularly large one, a time exposure from some distance away will capture an overall picture. Put your camera on a tripod, set the f-stop at 8 or 11 and open the shutter for 8 seconds. You'll get a lot of bright flame with such an exposure, but the flame light will also serve to light the surroundings.

All of the daytime cautions apply at night—doubly so since you often can't see where you are walking or what is overhead.

There are few news incidents more exciting than a fire—witness the crowds. Most firemen love having their pictures taken while fighting a fire, and will bend over backwards to cooperate. Getting a police monitor and monitoring the fire frequency 24 hours a day will inevitably pay off with dramatic pictures.

9
Sports Photography

Sports. Few subjects so stir photographers. The dramatic life elements present include: tension, competition, the thrill of victory, and the agony of defeat. But most of all, sports offers the photographer the ultimate challenge of capturing a decisive moment.

That moment may be the clutch catch in a football game, the instant a high jumper clears a bar, the mid-point of a gymnast's leap, the pickoff at second base, the rider being pitched from a rodeo horse, the stylish peak of a surfer's ride, the accident that mars an auto race.

Here are some tips on how to best capture the most exciting moments in each unique sporting event:

Auto Racing. Long lenses are most useful. Zooms will help you fill the frame, but usually you'll be able to move freely around a track, so they are not a must. I prefer 200 mm to 500 mm lenses. Panning the action produces good pictures. Shoot at least a few tight close-ups of drivers during pit stops. Head-on shots from the tip of a hairpin turn are impressive, but I was present in 1955 when a newspaper photographer was killed by a car that overturned on top of him in a turn. Be careful. A motor drive is helpful but not essential. I recommend using fast film.

Baseball. Your best position is probably behind first base. From there, you can use a 300 mm or 400 mm lens

to shoot home and second-base action. Shots from behind the plate are made behind a screen with about a 200 mm lens. Shots from center field to show the pitcher, batter, and catcher are made with a 1000 mm lens. Any time a man is on first base with one or fewer outs, a potentially exciting situation exists for a play at second base. In this event, prefocus the lens before the play begins. Use fast film. A motor drive is very important for capturing the action.

Basketball. This is an easy sport to photograph. A normal 50 mm lens or even a moderate wide angle such as a 35 mm can be used. Available light is usually sufficient if Tri-X film is used with Acufine developer. Electronic flash helps create a jet-black background, which some photographers like. (I don't.) The best action is usually fights on the backboard as the big men go after rebounds. But don't neglect the driving lay-up by the guard, or the jump shot of the forward. Some fine expressions are often available from opposing coaches. A motor drive is helpful but not essential. Focus is rarely a problem with the shorter lenses.

Bicycling. Panning road races captures the feeling of speed enjoyed by the racers. Work from a distance with a 135 mm or 200 mm lens. Corners can be covered by short lenses of 20 mm or 28 mm focal length. Children's bicycle motocross (BMX) is an exciting new sport with all the action of motorcycle motocross. Use fast film and high shutter speeds to capture the action. A zoom lens is most helpful. Watch for accidents on the first turn. Snap a few tight close-ups of the kiddie racers in their helmets, goggles, and face shields.

Boxing. Because of the fast action involved, boxing is a difficult sport to photograph. At a hometown match, you will probably be able to shoot from the ring apron with a 35 mm lens. But put a second man some distance back with a longer (perhaps 200 mm) lens. Watch the action carefully. Look for an opening on the part of either fighter, and then anticipate the blow. Available light is usually sufficient. Strobe, however, will freeze even perspiration flying away from a face and might be desirable if permitted. (Check with a fight promoter first.) Use fast film, push-processed. A motor drive is not really needed.

Equestrian Sports. Grand prix hunting and jumping is an exciting sport of the blue-blooded rich. You'll have to work outside the ring with something like a 300 mm lens. It is possible to work closer to some jumps with a 135 mm lens or even a 50 mm lens, but your photo opportunities will be limited without the longer lens. Peak action should be easy to capture. Watch for a horse that balks at a jump;

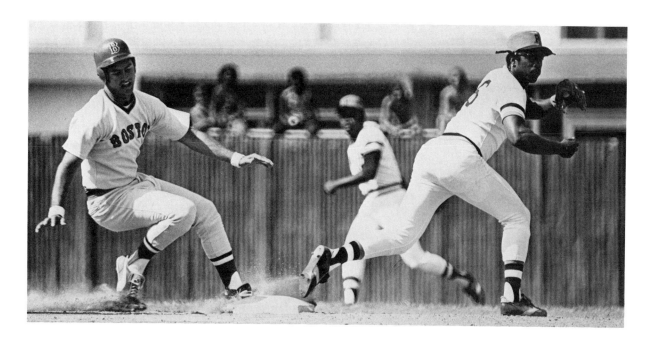

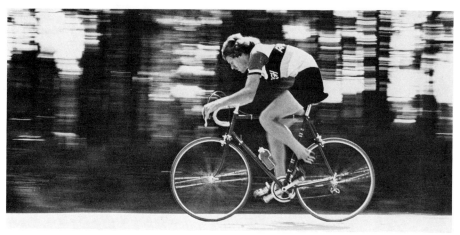

Although sports injuries are frequent, pictures taken at the instant of an injury are extremely rare. In this picture (below) of Fred Lynn, star slugger of the Boston Red Sox, look carefully at Lynn's left foot. He was returning to second base and could not slide due to an earlier injury. The spikes on Lynn's shoe caught on the bag and his foot twisted to a near 90-degree angle, tearing the muscles and ligaments. Data: Nikon F2 with motor drive, 500 mm Nikkor lens, 1/1000 sec. at f/8 on Tri-X film. Photo by Gene Page III. A bicycle racer is frozen against a blur of trees as he speeds past (above). To pan subjects moving at the relatively slow speeds of racing bicycles, shutter speeds of 1/60 sec. or slower are needed. Data: Nikon F, 105 mm lens, 1/60 sec. at f/22 on Plus-X film. Photo by Dick Dickinson.

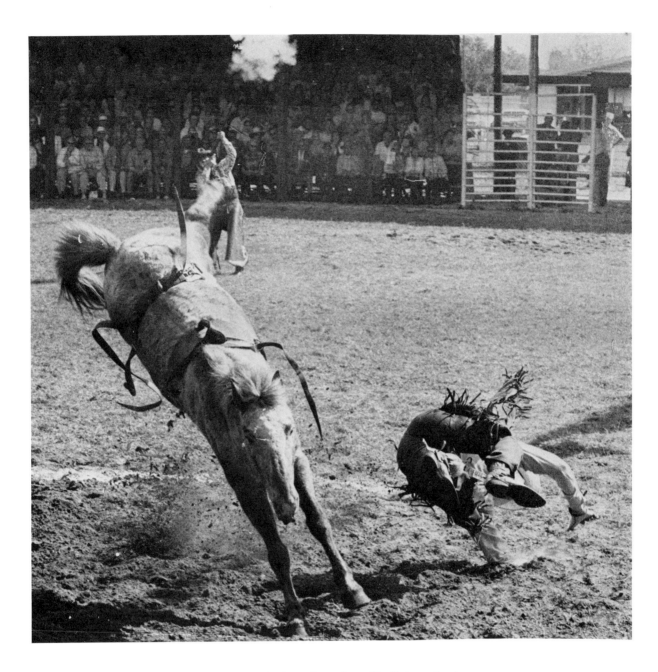

A clown blasts his shotgun as a rodeo rider bites the dust after a short ride. Rodeo action is fast and furious, but easy to capture on film. Sometimes the riders appear to fall in slow motion. Data: Nikon F, 80−200 zoom lens, 1/1000 sec. at f/11 on Tri-X film.

it might dump the rider over its head. Horse racing is most often photographed with either very long lenses from outside a turn, or with very short lenses from beneath the rail. A motor drive would be helpful.

Football. Football is *the* American sport. You'll work from the sidelines with no lens shorter than 135 mm. I prefer this lens for night games, but also like the 180 mm, the 300 mm, and the 500 mm for daylight games. The 500 mm is useful from the end zones for a unique viewpoint. Third down is critical; it's the pass play. If you're covering high-school football, it's probably easy to anticipate which player will be the pass target. Stay with him as he runs his pass pattern and wait for the lunge for the ball. If you follow most game plays, you may capture a mad scramble for a fumbled ball. A motor drive is essential for serious coverage. Super-speed Hulcher cameras, which shoot 50 pictures per second and cost $2000 at minimum, are used by the pros in critical games.

Golf. You'll probably prefer long lenses. I use a 500 mm, rather than fight the crowd. But do take along a few shorter lenses, such as a 135 mm. Watch for facial expressions after each shot. Sand traps produce the best action. A motor drive is not particularly needed but you will need a high shutter speed and fast film.

Gymnastics. This sport is about as difficult to photograph as indoor basketball. You'll need a 135 mm or 180 mm lens and will most likely have to stay off the court. Push processing is nearly essential. A motor drive is not needed. Look for peak action on each maneuver.

Hydroplane Racing. You'll need a 200 mm or longer lens. Check wind direction and then choose a location that allows you to shoot at a point where the boats will be turning into the wind. The boats bounce across the top of the water, and they are most likely to flip when the wind catches them under the bow and tosses them higher than expected. Other shots are pan-action ones. A motor drive is helpful.

Motorcycling. Apply the basic rules for photographing auto racing. Use long lenses. Watch the background and try to obtain clear sky for shots of cycles jumping. Fast shutter speeds are needed for all but road races, where pan shots may be utilized. Close-ups of motocross racers may be interesting if they are covered with their usual mud. Don't miss a sidecar race if one is near you. The action is fantastic.

Rodeo. I have separated this from equestrian sports because it's a mixed bag of events. Some rodeos allow photographers in the arena, but I warn you that this is very dangerous. I was

almost killed by a bull once while photographing arena action close-up with a 35 mm lens. Since then, I use an 80–200 mm zoom and a 500 mm lens from a great distance. Peak action is easy to catch as riders are thrown almost every time. Surely this won't escape even a novice photographer. A motor drive is very helpful, almost essential for serious coverage. The best events are saddle bronc riding and bull riding. Stay alert for the aftermath in case someone is hurt.

Sailing. This sport is best shot from the water, from a maneuverable powerboat. You should be able to use 28 mm, 35 mm, or normal lenses for these pictures. Keep the background free, if possible, of other types of boats. Longer lenses can be used for tight shots of trapeze action, but bouncing boats are not good platforms for using lenses beyond 200 mm. Sailing makes a spectacular subject for color photography.

Surfing. Some of the best shots have been taken with a wide-angle lens attached to a waterproofed camera on the nose of the board, but chances are all of your pictures will be made from shore. You'll need a 500 mm or 600 mm lens. If there is a jetty or groin nearby, you may be able to use a 135 mm or 200 mm from there. A boat is out of the question in the rough surf.

Swimming. This is most often shot from the side of the pool, but I prefer head-on shots from the ends. Choose a zone of action, prefocus, and wait for your swimmer. When he or she enters the zone, start the motor-drive camera. A classic swimming picture was made by Co Rentmeester when he snapped Mark Spitz from water level. Rentmeester was using a Hulcher sequence camera and had only five frames in focus from the many he fired off at the rate of 50 per second. Swimming is tough to picture well unless you work at it. But I like the tight shots well enough to take chances. Use fast shutter speeds and maximum f-stops ($f/22$ or $f/32$, even if you have to push the film in daylight to both stop the action and provide some depth of field).

Tennis. The best shooting position is from the net along the sideline. In all but major tournaments, you should be allowed near that point. Use a 135 mm lens to cover the action near the back line. I shared this vantage point with a *Time* magazine photographer at a Chris Evert–Evonne Goolagong match. The only difference was he was using a Hulcher camera to shoot a cover of Evert. Be sure to get some shots of the stars serving.

Tennis great Chris Evert is shown on the way to one of her many victories during the women's tennis tour. There are no "tricks" to tennis photography and the only requirement is a reflex system capable of snapping the picture as the ball approaches or leaves the racket. Data: Nikon F with motor drive, 135 mm lens, 1/1000 sec. at $f/8$ on Tri-X film.

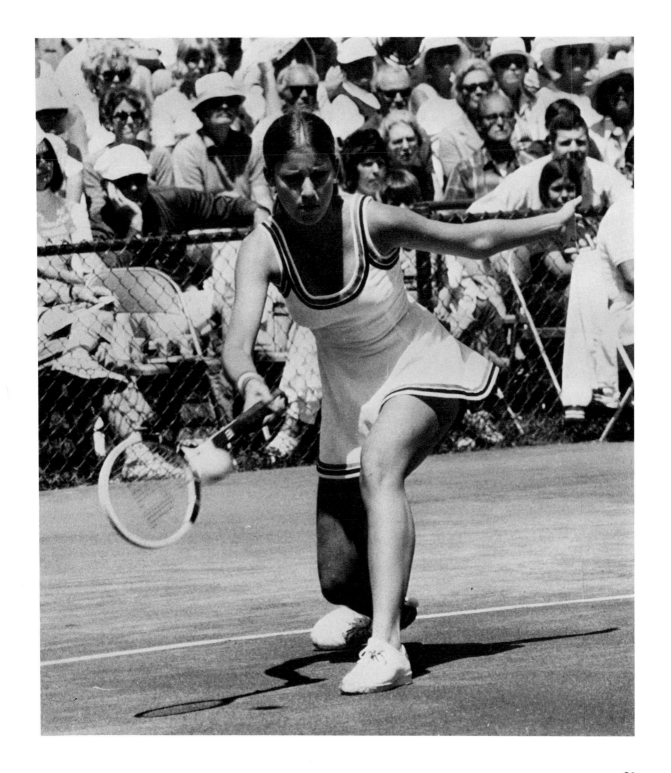

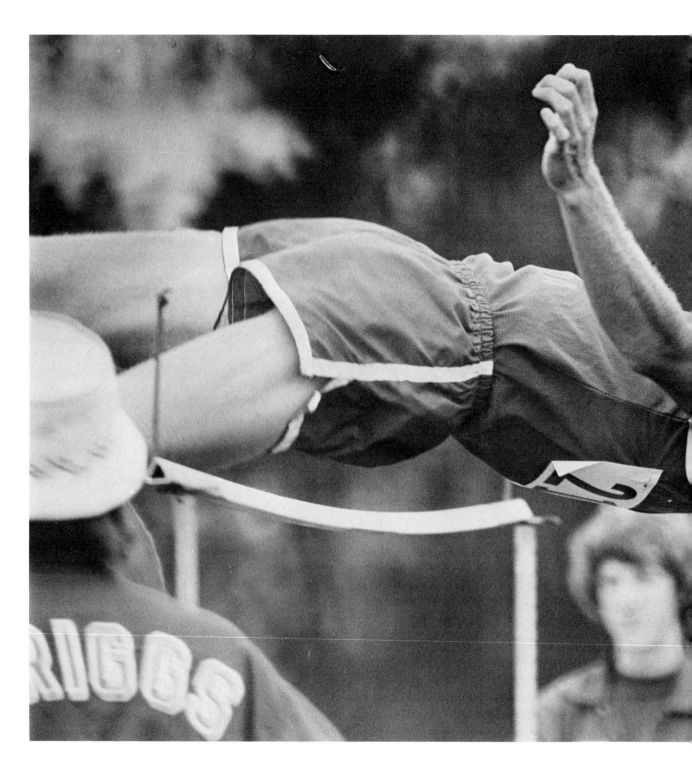

Track and Field. This category covers many, many sports, but almost all of them require a long lens for coverage. At small town meets though, chances are you will be allowed to shoot with wide angles close to the action. This may appeal to you for sports such as the high jump. I've included an action shot of a high jumper that I did with a 500 mm lens—just to be different because everyone else was using 20 mm lenses. For running events, shoot the field head-on at the finish line to capture expressions. Jumpers are best shot from the side, although broad jumpers can be handled head-on also. Hurdlers can be pictured from any angle. Pole vaulters are best pictured from a distance to avoid looking straight up at them and losing all perspective of their height. Use fast film and fast shutter speeds. A motor drive is very helpful.

Water Skiing. The best location from which to shoot is the tow boat or an adjacent boat. Slalom runs are particularly exciting, with water sprayed in incredible rooster tails behind the skiers. A shot of the frozen water behind the slalom skier has become a cliché, but it's always spectacular. Recently I was impressed by a pan shot of a slalom skier with the water a soft

Other photographers at the track meet were using wide angles, so the way to have a "different" picture was to shoot through a long telephoto lens. Data: Nikon F with motor drive, 500 mm lens, 1/1000 sec. at $f/8$ on Tri-X film.

blur. Flip Schulke, a pioneer underwater photographer, did some fantastic underwater views of skiers passing overhead. For a ski-jumping event once, I had a boat take me out to the ramp and leave me there. I crawled under the ramp, which was open at the high end, and waited there with a camera and 28 mm lens. I could hear the tow boat approach, see it come into view almost at the instant when, with a loud thump, the first jumper struck the ramp. He ripped across the boards over my head and then was airborne. I shot all the jumpers from a crouched position beneath the ramp and caught one jumper who lost his skis. Next time I'd love to be allowed to float a little beyond the ramp, perhaps on an inner tube, to catch views of the jumpers as they leave the ramp. Maybe with a fisheye—pointed straight up!

Wrestling. See Biz, Show.

Oops. This water-ski jumper seems to have lost something. The photographer was perched beneath the ski jump and caught this image of a jumper who was obviously clowning around. Data: Nikkorex F, 28 mm lens, 1/500 sec. at f/11 on Tri-X film.

10
Available-Light Football at Night

Perhaps few problems perplex the photographer as much as the one of obtaining good pictures of sports events held in low-light conditions. High-school football and basketball are particularly difficult to shoot as available-light events. Use of a strobe light, unless handled by someone with the skill of *Sports Illustrated*'s John Zimmerman, falls flat because it looks so obviously artificial.

But what happens when you walk out onto the field before the game, take a reading with Tri-X at ASA 400, and the exposure meter's needle won't even budge off its peg?

Both football and basketball are sports of rapid movement. You will need a shutter speed of at least 1/250 sec. to capture the action in a frozen or near-frozen state. The problem is to get that kind of shutter speed in a situation that reads 1/30 sec. at $f/2$.

The first step is to see if an ASA rating of 1200 will help. If that cures your exposure problem, then switch to Acufine developer and meter the scene at 1200. Develop as directed by the Acufine instruction sheet.

But what if that is still not enough? There comes a point of diminishing return with Acufine, and every photographer will have to experiment and determine for himself where that point lies. For me it happens at about ASA 1600–2000, so Acufine is not always so fine in extremely dim light.

This can be a real problem, as

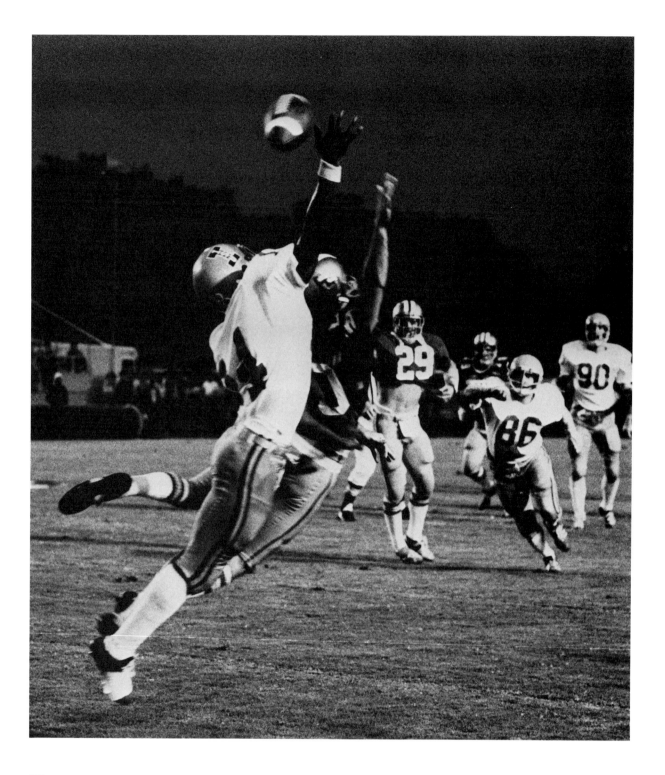

The lunge for the football shows the good action-stopping ability of 1/250 sec., the minimum shutter speed needed for any action or sports picture (left). It can be used effectively in dim lighting only with the help of high-powered developers that push film to its outer limits. Data: Nikon F, 135 mm lens, 1/250 sec. at f/4 on Tri-X film rated at ASA 4000. The lighting in this football stadium was so dim it was difficult to obtain a reading from the Cadmium sulfide meter (above). At the normal ASA 400, the reading was impossible for all but static, tripod-mounted camera work. So the film was rated at ASA 4000 to 8000 and the development was adjusted accordingly. Data: Nikon F with motor drive, 105 mm lens, 1/250 sec. at f/4 on Tri-X film rated at ASA 4000.

your readers probably won't appreciate the dismal pictures you produce. They were able to see the action without any problem, and television cameras, which amplify the weakest signal to produce a good image, have no problem capturing it; the problem is yours.

There are any number of developers on the market that claim to greatly boost film speed. And you can push film 4 times its normal rating by increasing development time 60 percent. But you still want more speed.

I've experimented over the years with many developer combinations

tions in the search for more speed and have come up with one that registers between ASA 4000 and ASA 8000. Here's the formula to tuck away on your darkroom wall. Measure by volume:

> 1 ounce of sodium sulfite (powder).
> 15 ounces of bottled water.
> 1 ounce of HC-110R.

Develop for 6 minutes at 70 degrees. This is a one-shot developer, so pour it out after use. The 16-plus ounces of developer will handle two rolls of 35 mm film.

This super formula allows me to shoot at 1/250 sec. at $f/4$ under high-school stadium lights. When the action takes place in mid-field, where the brightest light falls, I shoot at 1/500 sec. The end zones require 1/125 sec.

You can use this developer under any available-light circumstance that resists the Acufine developer treatment. Acufine is a good developer, mind you, and many newspapers use it as the standard developer. (We use D-76.) But sometimes you will find the need for the extreme film push processing just described.

This process results in a print with what I call moderate grain. Most of the time the grain buildup using this formula is not objectionable. Do not expect the fine grain normally produced by Tri-X at ASA 400. But do expect much improved football pictures.

11

Darkroom Drag Racer

There is an inherent excitement in darkroom experimentation, much like that accompanying scientific exploration and discovery. A creative photographer can even "invent" a picture in the darkroom. By practiced manipulation of the printing process, the photographer can change reality to suit his or her psychological interpretation of the subject.

That is what I did with this picture. The subject was drag racing's "funny cars." The resulting "photo-illustration," although not "factually correct," is psychologically accurate.

And the resulting picture created as much a stir as I've ever had with any picture. I found I had an instant reputation in the area as *the* drag racing photographer—a title to which I had not aspired.

The assignment began with coverage of Snowbird National drag races held at a strip near our city. A photographer who has covered drag racing in the past tends to become tired of the subject. New pictures are hard to come by.

In my case, I thought I had done it all. I had shot the essays, used all the wild lenses for special effects, and had even been proud of some of the pictures. But the assignment had to be met.

I shot the usual—burn-outs, off-the-line starts, close-ups of asbestos-suited drivers, overalls of the large crowd. The negatives were developed and the picture-printing process began.

Although the pictures were as good as those normally seen in drag racing fan magazines, something was missing.

The missing element was the "feeling" created by watching and experiencing a funny car. A funny car, in case you aren't familiar with drag racing, is the ultimate "full body" drag racer. Its engine develops more than 1000 horsepower. The car body is light-weight fiberglass and lifts upward to let the driver enter. It is simply a dragster with a light cover.

The noise created is deafening, much louder than that created by a commercial jet heard from the same distance. The illusion of power overwhelms the senses. The rear tires spin furiously, and smoke swirls in great white clouds from beneath the car as it

This is a near-straight print of the Blue Max funny car smoking its tires at a drag strip. A good picture, slightly enlarged during printing, the background has been burned in to darken unwanted elements. But this picture can be improved. Data: Nikon F with motor drive, 200 mm lens, 1/1000 sec. at f/4 on Tri-X film.

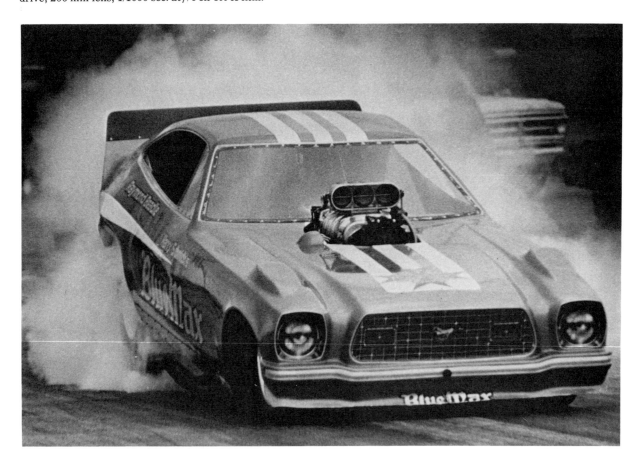

shoots forward in terrifying acceleration. In 6 seconds, the funny car can travel from 0 to 200 miles per hour. The earth seems to shake and the stomach quivers as the engine revs higher. The whole car appears about to explode in anticipation of the quarter-mile run ahead.

All that excitement was absent in my first print of the "Blue Max," one of the world's fastest and most beautiful funny cars. The original picture was taken at 1/1000 sec. at $f/4$ on a miserable, overcast day. The car was "burning out," spinning its tires in bleach to clean and heat them. Smoke billowed around the car. But the picture was still too static.

To put more feeling into the picture I began with the idea that at least part

This is *the* picture of a funny car. The car fairly screams its defiance of earth's gravity as its tires spin furiously on the pavement. To create the "explosion" effect, the enlarger was racked upward out of focus during printing.

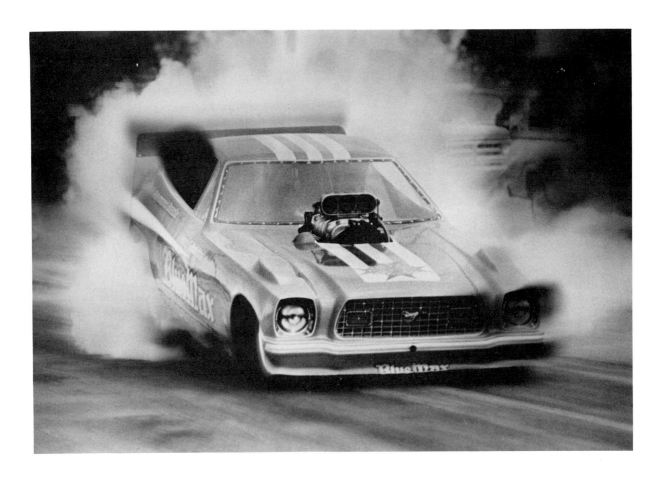

of the car must appear to be moving. Since the image was frozen, the "motion" had to be added in the darkroom. After a few false starts, I remembered a trick I had learned six years before but had never used. As with all photo tricks, it should only be used when it contributes to an exact end result.

I first cupped my hands to "hold back" the exposure given everything but the center of the picture, to ensure an area of sharpness. Then I used a piece of cardboard on a coat hanger wire to "hold back" the center while I exposed the outer edges. Now was the time for my trick. While doing this second exposure, I slowly racked the enlarger upward, throwing the image out of focus. In so doing, the outer edges blurred out from the center, creating the effect of an explosion.

The only difficult thing about this trick is effectively hiding the area of transition from one exposure to another. It requires quite exact timing and movement of the hands and cardboard.

It took several sheets of paper to produce the image I had in my mind. I wanted a dark image to create an ominous feeling. (In photographic terms, dark is evil and light is angelic.) The final step in printing was to burn in or darken the upper edges of the picture to eliminate some distracting background elements.

The finished picture allows you to experience my original feeling that the Blue Max is a gem, placed against a satin setting, snorting and pawing the ground like a raging bull moments before the charge.

12

Copying, Copying

What do you do when somebody walks into your office with a treasured photograph and wants it in the paper? If you accept the picture, crop it with red crayon, and slap a sticker on the back to indicate size, then you can go directly to jail without collecting $200.

Or, suppose someone shows up with a dramatic color slide you'd like to use. If you say, "sorry, we can't handle color slides," you may lose a good picture.

Photo copying is a simple solution to both problems.

I use a device that costs less than $12.

My favorite lens for photo copying, indeed for almost any chore requiring incredible resolution, is the 55 mm Micro Nikkor. This remarkable lens focuses to life size on the negative and provides unparalleled clarity. Micro lenses by other manufacturers have similar capabilities.

If someone brings a color or black-and-white print to your office and you can copy it easily and quickly within one minute, your efficiency will be greatly appreciated.

If the person happens to be president of the local historical society, you may be on the threshold of something good. There are probably lots more interesting pictures on file, and having been so impressed by your efficient handling and concern, this person may well open the magic files to you.

If the print is not glossy, you have

To copy color slides, this setup is quite desirable. First an M-ring is placed on a Nikon F, followed by a Micro Nikkor lens. The rear half of a series 7 filter holder goes on the front of the lens, followed by an Accura Slide Duplicator. With this combination, you can copy black-and-white pictures from color slides.

no problems at all. Just lay it flat on a desk, measure the exposure reading, set the camera, focus, and shoot. Bracket one *f*-stop above and below the indicated exposure and simply return the original.

If the print is glossy, you must worry about reflections on the print surface. Lights placed at 45-degree angles will kill most reflections. Another trick is to cut a lens-size hole in a large piece of black cardboard and then slide the cardboard over the lens.

With close-up photography, the cardboard is so close to the print that it blocks out other items that might reflect. The cardboard won't reflect either. Remember to return the print.

Nothing could be easier than copying prints; a lens does all your calculations for you. Of course you can use bellows or close-up filters for copying, but I have used them all and nothing excels the Micro Nikkor I bought used for $75.

If the copy object is a color slide, then you need an accessory such as I ordered from Spiratone many years ago for about $12 called an Accura slide duplicator.

It fits in front of the micro lens, holds the slide or filmstrip in place, is adjustable for exact focusing, but contains no lens of its own.

To set up the duplicating device, I first put on the camera the M-ring supplied with the Micro Nikkor. This is like extension rings available for close-up photography, but comes fitted for the Micro Nikkor. Next I put on the Micro lens itself, and onto the front of the lens I added the rear half of a Series 7 filter holder. And finally, I placed the slide-copying attachment onto the filter holder.

I suggest you use a camera with a built-in exposure meter if at all possible. The devices you have added do cut exposure unpredictably.

I insert the slide into the copy holder, then go outside and aim the camera at a white wall. A normal daylight exposure is 1/1000 sec. at f/11 with Tri-X film; the copy reading is 1/60 sec. at f/22. Since the slide is locked in place on the lens, you at least don't have to worry about camera movement. You could hand hold a second or more if you needed to.

Slide copying is really quite simple and quickly produces a black-and-white negative from a color positive. If you have a color negative, special printing paper is available to print a black-and-white-positive. I suggest you keep some on hand.

Copying movie film is a lot tougher. A special copy device is available to handle this chore, but such instances crop up so infrequently the devices just won't pay for themselves. There is another solution, however. Project the film until it is just large enough to copy. Use a movie projector with a provision to freeze a single frame. When you have found the frame you want, freeze the projector and take a reflected exposure reading from the movie screen. Stand behind the projector and shoot the projected image.

This negative is not as good as print or slide copies because you have picked up the screen pattern and you have greatly enlarged the tiny movie image. But you'll at least produce a picture, and sometimes a surprisingly good one.

You can use the same procedure with 8 mm, Super 8, or 16 mm movie film. Should you need to copy a 35 mm movie frame, which has a different format than the 35 mm still image, use the copy device for slides since it has a filmstrip provision. (Filmstrips use still another format.) If your copy is not

exactly perfect, just enlarge the image in the darkroom to get rid of superfluous matter on the top, sides, or bottom of the negative.

Now we've handled black-and-white prints, color prints, color slides, color negatives, and movie film, but someday you may find yourself copying a blueprint. If you've done so in the past, you've probably been disappointed that the ink lines didn't stand out from the blueprint. It looked good in natural color, but your black-and-white film saw that blue as a very dark gray against which the black ink simply didn't stand out.

To solve the problem, use a blue filter while photographing the blueprint. A blue filter lightens a blue color for black-and-white work. The blueprint becomes a very light gray and the black lines stand out nicely.

Perhaps your copy problem is a very old picture that has yellowed with age. This darkening cuts contrast when you make a photo copy and everyone is disappointed at how poorly you did at copying a perfectly clear picture.

This problem is the same as with the blueprint, and the solution is the same. The yellowing comes out gray in the black-and-white print. If you put a yellow filter on your lens, you'll wonder where the yellow went.

Now you've become a photo genius. Keep in mind that when copying old pictures, you can perform some cropping while copying. You can come in closer on grandma's face, print the copy about 4″ × 5″, sepia-tone it, and grandpa will be forever appreciative. You can even use an antique circular frame to hold the picture and give it as a Christmas present.

If the old picture is really a mess—there are numerous good books available on photo-retouching. Buy one and become an artist.

To copy movie film, a good solution is to use a movie projector with a provision to freeze a single frame. When you have located the desired frame, freeze the projector and take a reflected exposure reading from the movie screen.

13

Radio-Controlled Strobe

If you try what I tried—radio-controlled strobe control—you'll wonder if there is anyone in this land who has not purchased a Citizens Band radio.

Several years ago a compact two-piece unit with a Kenlock brand name appeared on the market, advertising itself as a radio control unit for cameras. One piece was a tiny transmitter with antenna; the second was a larger receiver with antenna. The unit could fire either motor-drive cameras with an electrical relay connection or regular cameras by tripping a solenoid cable release.

I watched the initial price (always steep) drop until it seemed to bottom out at $25, and then purchased mine. After all, I had seen other radio units advertised for between $700 and $900. Twenty-five dollars seemed terrifically reasonable.

But perhaps you get what you pay for. First, there was the matter of limited range. The units were advertised as being good over a one-quarter mile range, but my own experience didn't prove this. Mine were only good for a range of about 300 to 500 feet—maximum.

The idea is to connect the receiver unit to your camera and fire the camera from a distance by triggering the transmitter unit. My first test was at the local drag strip, where national stars in the sport routinely compete. I obtained permission to set up a Panon

(140-degree, super wide-angle camera with a swinging lens) in front of the "Christmas tree," a light device that signals the dragsters to start.

The Panon was to be controlled by my radio transmitter. Tests before the races showed no problems. I could stand off to one side, behind the protective railing, and fire the camera.

But once the dragsters pulled up to the line, snorting and bellowing with their massive engines, trouble began.

To state the problem quite simply, the dragster engines triggered my camera in unpredictable fashion. The ignition systems of the dragsters gen-

erated such a powerful electromagnetic field that the radio device "thought" it was receiving my signal. Alas, nothing good came from my effort.

Next, I used the radio device connected to a tape recorder. The governor was in town for an annual address before a luncheon of bigwigs and I taped the speech, controlling the recorder from a comfortable position at my dining table.

Pretesting again showed no problem. The recorder came on and turned off on signal from my table during the tests.

But during the actual speech

A portable CB radio with a remote microphone can be linked to the synch terminal of a camera for radio-controlled strobe lighting. At left a strobe synch cord and a microphone cord were cut and then spliced together to join the Nikon F and the radio. When the Nikon F is fired, it closes a contact that causes the CB radio to emit a short beep tone, triggering a remote CB receiver. The CB receiver is located with the strobe and joined by a wire. Radio control can also be used to fire a remote camera in the same fashion as the strobe at right.

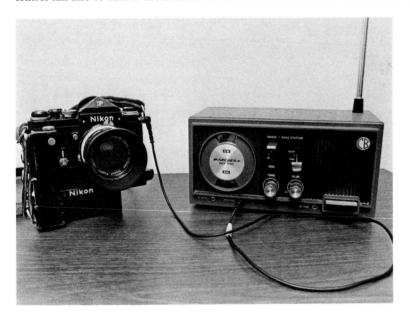 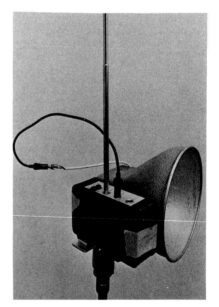

something inexplicable happened, and the recorder started and stopped as if on whim. Without a pad full of backup notes, I would have had some tall explaining to do. Anyone working as both photographer and reporter has two jobs to do at once. I had hoped the radio-controlled tape would solve the reporting chore so I would be free to concentrate on pictures.

I refused to even look at the entire unit for months. Finally, about a year later, I pulled it out again and the transmitter wouldn't transmit. I have no idea to this day what is wrong; I simply explain that it's broken.

I then bought some walkie-talkies for my kids. One of the units was a large radio that transmitted on CB Channel 14, the same frequency the receiver was on. Lo and behold, the receiver worked fine. Not only did it work, the new radio gave it tremendous additional range. Now I could trigger the camera from almost a quarter-mile away.

The more I thought about it, though, the more convinced I became that by triggering the camera I wasn't making the best use of this equipment. Almost every picture situation I've ever been in has been improved if the photographer himself has hand held the camera and snapped the picture.

I decided to experiment with using the radio units to fire a strobe; not an original idea by any means. John Zimmerman of *Sports Illustrated* some-

times used radio-controlled strobes to light huge areas. (But he, too, preferred wiring the area to avoid any possible unforeseen problems with the radio units.) The *Miami Herald* used to light the Orange Bowl with strobes set off by radio signal from a camera on the field.

All that is required to connect the two units (camera and transmitter) is one cord spliced together. First cut a strobe cord in two; then cut a microphone cord in two. Both cords contain two wires. Wrap the two, test the radio, and then solder the connections. Finally, wrap electrical tape around each connection (to avoid shorting them out) and then tape the entire area together.

To use the unit, plug the strobe cord into the camera's synch outlet and the other end into the walkie-talkie's microphone outlet. When the shutter is triggered, a contact is made at the synch outlet that triggers the radio to transmit a signal to the receiver unit. The receiver closes a relay that completes the circuit in the strobe, firing it.

The time delay is such that you must use one slower shutter-speed setting than normally used for strobe. If your camera synchs at 1/60 sec., you must now use 1/30 sec.

The first big test of my new setup came when the local historical society announced plans to move the area's first church some two blocks to a new historical park. The move would take place at about midnight, to avoid tying up traffic during daylight hours.

I wanted to light about half a city block. The key to the arrangement would be radio control of one strobe. That strobe then would trigger four others equipped with light slaves. At 11:30 P.M., I arrived on the scene to set up the lights. I finished a half hour later, and after some misfires because of misdirected light slaves, I was ready. But the church movers weren't.

The night dragged on until 3 A.M. when the first part of the move—an old courthouse—got underway. When the building moved into the area preselected for our picture, I triggered the camera.

Fantastic! Five strobes went off— two aimed at the courthouse, two crossing each other to light the surroundings, and one aimed at road signs to identify the location.

But the first hint of problems came when the strobes only triggered once on command. I tried three times, getting only one picture before the building moved through my strobe area.

The problem was humidity, which in Florida, at night, can be very heavy. Everything was wet—camera, strobes, and radio control unit. And nothing is as great an enemy of electronic devices as moisture.

The moving of this church at night created a need for radio-controlled strobe. The radio would trigger one strobe, which in turn would fire four others equipped with light slaves. Although the system didn't work as planned, this picture shows the desired result.

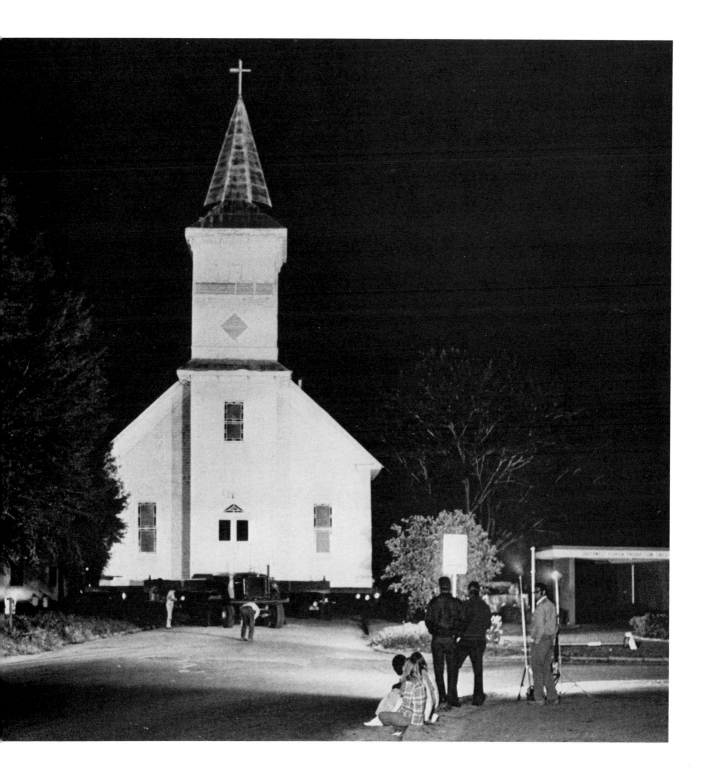

By the time the church came through an hour later, the radio unit refused to work. I hastily strung another strobe and used it off the camera to trigger the other four strobes. It worked, but gave me light in the foreground that I really didn't want.

I had been testing the radio unit for four hours, and for three of those hours it had worked fine in excessive humidity. There was one small problem, however. Every time a trucker passed through the intersection, the driver would reach for his CB radio to tell other drivers about this weird church moving down the street. "That's a big 10-4, good buddy. A *church*?" Each time, my lights would trigger.

14

2.5 Seconds of Action

It isn't often we of the press have a scheduled dramatic news event to photograph. It seems we forever arrive at the scene after an event, and must photograph action remotely related to the peak drama or excitement.

However, when one of the most historic old hotels in my town was demolished to "make way for progress," I had the opportunity to take dramatic pictures of destruction as it happened. Since the event was to last not more than four seconds, there would be no room for error.

Unlike a reporter, who can always return to a source, phone for another viewpoint, or use the library to research background for a story, the photographer is under considerable pressure. He has but one chance to get his picture and knows that his individual merit will be judged against peer competition.

So the Hotel Dixie Grande pictures assumed importance in more ways than one. I wanted first, as always, to communicate clearly with our readers. But competitive factors were surely present also.

Preparation for the Dixie Grande "implosion" began with conversations with the principals involved. In order to work very close to them, to enjoy special privileges, they had to come to know me and trust me.

For days, I spent every spare hour watching them work, asking questions, learning something of what would

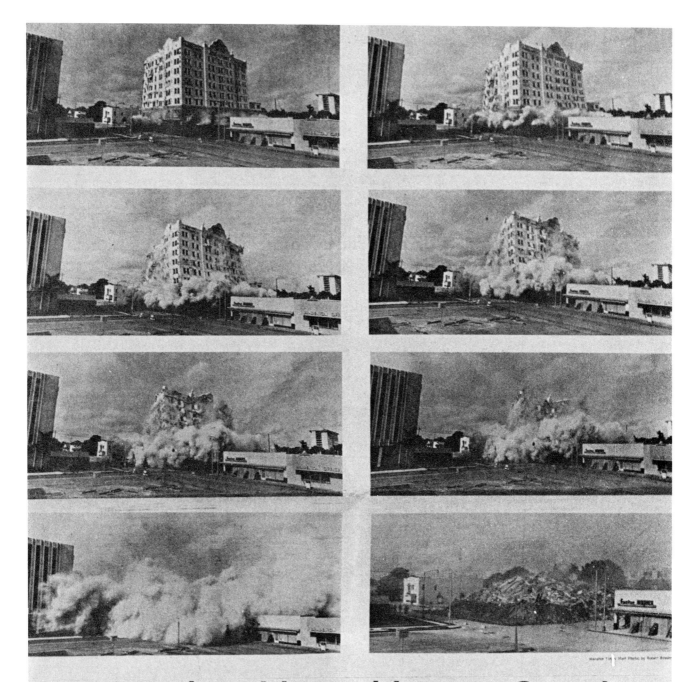

The day they blew old Dixie Grande up

More photos, Page 3

By DON AKCHIN

remarked, three people may keep a secret — if two are dead. In the course of an-

tators were watching. The show was brief but awesome.

sharp explosion crashed through the silence. The walls swiftly collapsed and disap-

FOR JACK LOIZEAUX and his family firm, Controlled Demolition Inc. had demon-

where the debris was to fall. A wall of dirt 12 feet high was pushed up against the north

area, which extended one block in every direction. THE BLAST was delayed

boom. The concrete and steel supports holding up the structure were blown away, al-

The front page of the *Manatee Times* graphically displays the result of 2.5 seconds of building demolition. The bottom left picture shows the cloud of caustic lime dust that enveloped photographers shortly after the picture was snapped. Data for all pictures except bottom right: Nikon F with motor drive, 20 mm lens, 1/1000 sec. at f/8 on Tri-X film. Bottom right: Nikkorex F, 35 mm lens, 1/1000 sec. at f/8 on Tri-X film.

84

happen in the four seconds when the nine-story building would fold in on itself. I learned that there were three men who handled the placement of the explosives ... and that cooperation from the wife of one of the men was critical to any notion that I be allowed near the men when the blast was triggered. So I chatted over morning coffee with her in her mobile home each day for a week.

As the day approached, I got up early to walk the streets and alleys surrounding the hotel to select a favored spot. The blast was to go off at 7 A.M. on a Sunday. So I arose at 7 A.M. the morning before to check the angle of the early morning light, the shadow play on the buildings, the meter reading for my film. When your picture opportunity will be over in four seconds or less, nothing can be left to chance.

My spot selected, I obtained permission to use it from the "master blaster." Fortunately, he had chosen the same spot, a parking lot northeast of the hotel, to trigger the blasts.

He cleared my choice and issued special passes to allow me into the forbidden zone (a four-block area that would be sealed off with a heavy police guard).

As a final goodwill chore, I helped Mark Loizeaux, a son of the head man, load the dynamite and blasting caps—more than 300 pounds of it—into a laundry cart, of all things, which we pushed and shoved a half-block to the hotel. If the passing cars had only known what was in that laundry cart. . . .

I waited awhile longer as Mark rammed the dynamite into holes drilled into the support columns of the hotel, attached the caps and wires, and trailed the wires off toward the detonator.

I would not allow only one photographer to be responsible for such an important event. In all, I used four photographers—me in the parking lot, another on a roof two blocks away, and two in another parking lot from which they had a clear view.

The night before the blast was a time for preparation. One of the demolition crew briefed me ahead of time "over coffee" that the old building contained a large amount of lime. Lime is caustic to camera lenses, and will eat the coating off them. The dust storm following the blast can send particles deep into a camera. In fact, a similar dust cloud had once ruined a camera owned by Mark Loizeaux.

I began to make my camera dustproof. At a drugstore, I purchased a circular piece of glass designed for a flashlight, a glass that perfectly covered the front of a 20 mm lens, and attached it with tape. I purchased a latex glove, the surgical variety, and snipped off the finger part. I taped into place a piece that snugly covered the rest of the lens, with a small roll of rubber hooking over the front glass piece.

I wrapped the body of my motor drive in a transparent plastic wrap, several layers thick, and taped it tight. This transparent and quite flexible material allows a change of camera settings if needed. The camera probably wasn't waterproof, but I felt it was sufficiently dust-proof. And it was easy to handle.

The day of the blast dawned bright and only partly cloudy. A large crowd had learned of the time through a news leak on a radio station and had gathered behind a cordon of police. (The blasters had not wanted the time announced.) The police were jittery and more than one photographer had a rough time reaching his assigned spot as nervous auxiliary officers, ignoring the difficult-to-obtain special passes, tried to prohibit anyone from entering that area.

The time for the blast came and went as I learned someone had accidentally cut one of the wires leading to a dynamite charge. With time to spare, I had a bulldozer hoist me up one story to a rooftop for a clearer view of the hotel. At 9:16 two long siren blasts cut through the air and the crowd quieted. Below me, head blaster Jack Loizeaux crouched behind the bulldozer, his hand on twin switches that would trigger the dynamite. At 9:17 there was one long siren; 45 seconds later, 3 sirens sounded and the 15-second countdown began.

The exposure meter read 1/1000 sec. at $f/8$. The day was sunny, casting shadows off the Dixie Grande, and puffy clouds billowed behind the old hotel. My motor drive with eight new batteries in it was ready, set for a continuous run of four pictures per second.

5 . . . 4 . . . 3 . . . 2 . . . 1. The concussion hit me like a hard slap in the chest as the loud "boom" sent the first puffs of dust from the base of the building. The shutter trigger was already down and the film was ripping through the camera. In less than 2.5 seconds, the building had disappeared into a dust cloud. I stopped the camera at 20 exposures, as the choking dust swirled over me.

Hours and hours of preparation were over in 2.5 seconds. The pictures on the film were either good or some future explanations would be required. An hour later I knew they were good.

The camera had done what the eye could not. It had frozen the death throes of the grand hotel, frame by frame, for studied observation. It had created images that could be viewed by the thousands who did not attend the blast. It had provided a study tool for Jack Loizeaux and his blast crew, who ordered a complete set. And the pictures were sought by our historical commission.

The 2.5 seconds captured on film was well worth the effort. The mental image I'll have the rest of my life would have been reward enough. The privilege of having been on the scene with a camera is one of journalism's rewards.

15

The Speed Magny Saves the Day

When the next Presidential election rolls around and you're assigned to cover the commander in chief, just don't say out loud, "I'm going to shoot the President today." Secret Service simply doesn't understand photographers' jargon.

The Bicentennial year was an election year, and every major candidate, including the President, came through my town. And unless your address is especially remote, that same entourage of candidates and media will be coming through your town once every four years. And when they come and you cover them, you'll discover a new world of elbow-to-elbow, tension-packed photojournalistic competition.

The President and the candidates are big news. They are followed by representatives of the three major networks, foreign television networks, and foreign news agencies. There may be as many as 200 press representatives roped off in a small area, all vying for the pictures. Although these are difficult circumstances, it can be fun.

Florida has an early and important primary, so those of us who live and work here get a sneak preview of the bedlam awaiting the rest of the nation. I'll tell you what to expect when it's your turn.

A Presidential visit is a major undertaking, even during a campaign. Secret Service will begin work a month ahead of time, checking possible overnight accomodations, looking up

known security risks, and generally paving the way.

You should stay in close contact with the local committee to elect or reelect the President. They will let you know when it is time to present information for credentials. These credentials are essential if you hope to work near the President.

Every person who will be assigned coverage of the President must submit name, home address, home phone, social security number, birthdate, birthplace, and race. This information is then passed through the federal computers of the FBI, CIA, and Secret Service. Unless you have a photographer with past membership in a subversive organization, you should have no trouble.

Our paper had trouble in 1976, however, accrediting a Cuban-born photographer on our staff. Despite the fact he was cleared on two occasions to photograph the President, he was rejected on a third attempt. And, yes, each time you cover such an event you must repeat the credential process.

Press passes must be picked up in person and identification is required. This may be as simple as obtaining a press card from your paper, or may extend to requests for your social security card and driver's license, as well as signing several forms.

Your first coverage will usually be at an airport. Your gadget bag and pockets will be searched, and you may be asked to fire your camera once or twice. Secret Service men will be everywhere, identifiable by small lapel pins and what appear to be hearing aids but are really radios. The microphones are hidden up their sleeves above their wrists.

You'll be herded into a roped-off area and told to stay there. It's up to you to jockey for position. You'll be competing with other local and national press representatives.

The President will probably hold a brief press conference. He will come within about six feet of the ropes that restrain you. A 50 mm or 105 mm lens will work fine.

Pool press workers will be allowed quite close when the President goes on a handshaking trip into a crowd. Select a good position and use a 24 mm, 28 mm, or 35 mm lens. Position is everything.

During a speech, the press will be positioned on a platform usually erected off to one side. Your distance to the President will be more than 100 feet, no problem for long television zoom lenses, but a problem for you. A 500 mm is needed; a 1000 mm on a tripod would be helpful. I use an 80–200 mm zoom and a 500 mm from the platform.

Presidential candidates don't have the same degree of security around them, although Secret Service will be well represented. Clearance, if any is needed, is usually granted on-the-spot.

George Wallace is caught in campaign action on Polaroid Type 107 film shot with a Speed Magny. Data: Nikon F2 with Speed Magny, 135 mm and 200 mm lenses, 1/250 sec. at f/11 on Type 107 Polaroid film.

Depending on the candidate, the distance between press and candidate will be as little as one foot or as much as ten feet. For overall shots, I used the 20 mm and 35 mm lenses. I shot close-up views of most of the candidates with a 135 mm or 200 mm lens. On every visit, my paper used two photographers; one shot in color to back up the main photographer shooting black-and-white pictures.

One 1976 visit brought a special problem. George Wallace was visiting the airport just 40 minutes before our scheduled deadline. We could stretch the deadline a bit, but it seemed everything would be working against us.

To begin with, the airport is 20 minutes from our branch office. Heavier-than-normal traffic made driving the film back for processing out

of the question. I knew we would have to fly 30 miles to St. Petersburg. But even processing on the plane was not feasible. We needed to arrive in St. Petersburg with prints.

Polaroid seemed an answer. But Polaroid cameras are no match for their film. Even the 180 and 195 professional models have only one fixed lens. The afternoon before the visit, while discussing the problem, I remembered a device made by Nikon called the Speed Magny.

The Speed Magny is a Polaroid back for a Nikon camera. The *Times* does not own one so I telephoned the headquarters of Nikon Professional Services and asked for the immediate loan of a Speed Magny 45 for a Nikon F.

The Nikon people searched around, said one wasn't available, but asked whether I would settle for a Speed Magny 100 for the Nikon F2 model. Since I didn't have an F2, they replied they would send me one. They also promised to send me a 50 mm, f/1.2 lens.

Eight hours later an airplane landed at our airport here with a Speed Magny, a Nikon F2, and a 50 mm, f/1.2 lens. Typical fantastic service available to Nikon Professional Service members.

The photographer covering the event would use Polaroid 107 black-and-white film, with an effective ASA of 160, in the Speed Magny. He bought three packs (approximately $3.75 each) containing eight shots per pack.

The morning of the Wallace visit we spent practicing shooting the bulky camera and timing development of the film. The prints were 3¼" × 4¼" each, smaller than the 4" × 5" prints of the Speed Magny 45. (The 45 also allows use of Polaroid P/N film that produces both a print and a 4" × 5" negative. It can also take 4" × 5" film sheets.)

The sharpness of the resulting prints was better than any Polaroid I've ever seen, but still below that obtainable through standard 35 mm film development and enlargement. But this was not time to be picky. These were *prints* that could be engraved immediately upon arrival in St. Petersburg.

The Speed Magny is about the size of an old 4 × 5 camera and attaches to the Nikon in place of the camera's back. The image comes through the camera lens, through a prism that deflects it downward, through an El-Nikkor *f*/2.8 enlarging lens onto a front, surface-coated mirror, then to the film plane.

Viewing is through-the-lens. Metering exposure continues through-the-lens also. The picture is snapped from the regular shutter release and the release cocked between shots.

The film is pulled from the camera by means of a tab. Development occurs outside the camera, making it possible to shoot many pictures in quick succession.

Through trial and error, I found that a 40-second development time gave the contrast I wanted. The information sheet with the film recommends 30 seconds.

To end the story, Wallace arrived 15 minutes late. *Manatee Times* photographer Dick Dickinson handled the Speed Magny chores with the aid of an assistant. I handled shooting 35 mm film, and we made our deadline with the help of a charter flight.

We found the 50 mm lens sent along was too short. Since most normal and wide-angle lenses will cause vignetting (darkening at all corners) with the Speed Magny, we were left with the telephoto lenses. Almost all of our pictures were made with the 135 mm *f*/2.8 Nikkor and 200 mm *f*/4 Nikkor lenses.

The Speed Magny proved a useful tool in this instance of extreme deadline pressure. If you're interested in buying one, they sell new for about $500. Used ones are sometimes available for around $250.

I wish George Wallace could know what trouble we "pointy-headed, liberal, pinko, news-media" people went to in order to deliver his message and pictures in the next morning's paper.

16

Night Creations

Half of each day is night. But how many night pictures do you take? How many nighttime scenes does your newspaper publish each day?

Probably not half. That would be unfair, because most of the news occurs during the day, when the "day people" are at work. But there are "night people" and their lives deserve depicting, too.

It's probably a safe assumption that you've neglected the hours of darkness. That's a shame because the harshness of the city in the sun is transformed into a new beauty in the soft glow of night lights.

Many photographers seem to have a fear of taking night pictures. After all, night exposures are almost impossible to meter, so the photographer feels his exposure may be hopelessly off correct densities. But the real truth, as I'll soon show you, is that night exposures allow for broad latitude.

Let's begin our experiments on the street. For an interesting night picture look for light. Light makes every picture you take, but you usually are concerned only with its direction and intensity. At night, it most often will be shining into your lens, and instead of illuminating the subject, will be virtually the subject of the picture.

Look particularly for moving lights, such as those found on carnival rides at the fair. As the light moves, it will trace a pattern on your film in a completely unpredictable fashion.

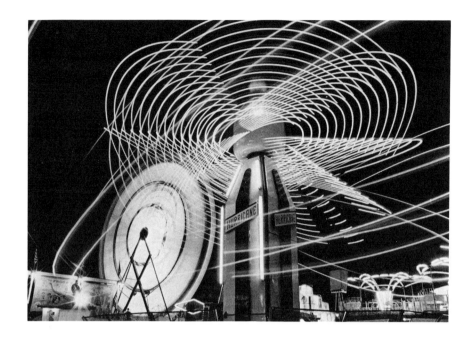

County fairs are fantasylands of swirling lights, begging for time exposures to allow their patterns to be traced onto film. A "hurricane" ride in the foreground is placed against a ferris wheel in the background. Data: Nikkorex F, 28 mm lens, about 10 seconds at f/8 on Tri-X film.

Look for subjects that move and are illuminated by light, such as waterfalls or fountains at city hall or tourist attractions in your town.

Look for patterns of lights that sketch an outline of a subject, such as the city at night.

As you can gather by the above examples, I'm talking about night pictures made without the use of "artificial" light (strobe or flash). You have only your camera, tripod, and film to depend on.

To begin determining exposure, try eight seconds at f/5.6 using Tri-X film. The camera should be set for time exposure and locked on a tripod. The eight-second time will provide good exposure in an area within a 15-foot radius of an ordinary streetlight. The light itself will be very dense on the negative, but surrounding objects will be correct.

It is important that the surrounding area have some illumination. A picture with only lights visible is generally unattractive.

Eight seconds at 5.6 is a good start. But as with much experimental photography, you should bracket your exposures. Many photographers start one stop less dense than they think correct and then double exposure with each successive picture.

All film is susceptible to a problem called reciprocity failure. Basically, this means the film becomes increasingly less sensitive to light as the expo-

sure time increases. Long time exposures become longer.

As the time exposure lengthens, the points of light within your picture assume the appearance of stars. Many photographers find this so attractive they duplicate the effect in short exposures by using a window screen over their lens, or a star filter purchased from a camera store.

But the filter won't produce the same soft overall effect of a long time exposure. So if you want to picture the city skyline or the local industrial polluter at night, you will have to turn the f/stop ring to about 22.

Now, if you figure out an equivalent exposure from the eight-second-at-f/5.6 rule, you would expose for about two minutes. But reciprocity failure is apt to make your negative come out too thin.

I have found the right amount of time to be as long as it takes me to smoke one cigarette. With the time exposure at f/22, I light my cigarette, smoke it, and close the shutter. Presto—I have proper density on the negative. (For non-smokers, that's four to five minutes.)

Before I leave the subject of what exposure to use, I need to cover one more factor. If the light within your picture is moving, as on a fair ride, you must use a wide f-stop (like 5.6). Since the light doesn't stay in one spot, an f-stop like 22 might not even register the moving light. Estimating f-stops for moving lights takes some practice before you regularly produce proper density tracings of the lights.

You'll have no trouble finding a subject for your night efforts. I mentioned fair rides. They are among the best subjects for lengthy time exposures. Nearly every ride is ringed with colorful lights, great for black-and-white or color photography. Since the lights are usually about 60 watts or more in intensity, you can use any f-stop from 5.6 to 16. Your exposure time will range from about 2 seconds to 30 seconds.

If you have a religion page, or you picture a "church of the week," you can break the usual monotony by photographing a well-lighted church at night. The first time I did this, the popularity of the picture was overwhelming. Photo orders reap extra money for your paper.

Searching for a picture to promote traffic safety on the Fourth of July, I remembered a roadside cross. I set up a tripod with a camera and made several exposures before a passing car pulled over. The driver approached me and I explained that his car was blocking the view of the road I needed to provide tracings of automobile taillights. He climbed back into his car and parked in a spot that would not interfere with my composition.

Again, he approached.

"My wife and daughter were killed here," he said.

And so began the story of the accident that resulted in the cross I was photographing. It was one of the most moving stories I'd heard in a long time, a story of loneliness and continuing sorrow brought about as the result of an accident that was not his young wife's fault.

I was a reporter when this picture was made, just learning to add photography to my skills. Need I say I had a story for July 4th drivers?

Two of these photographs were made shortly after I joined the *St. Petersburg Times* as a cub police reporter. My work ended at 2 A.M., so I had plenty of opportunities to practice night photography.

I was fortunate to have a company that realized film was the cheapest part of photography (and consequently provided unlimited supplies) and two friends who were willing to teach a neophyte how to develop and print.

This roadside cross marking the spot where two persons died in an auto accident was photographed from the side to include tracings of car lights passing behind it. The camera was locked open on a time setting, and a strobe was fired at the cross from the left side. Data: Nikkorex F, 50 mm lens, about 10 seconds at *f*/5.6 on Tri-X film with strobe fill.

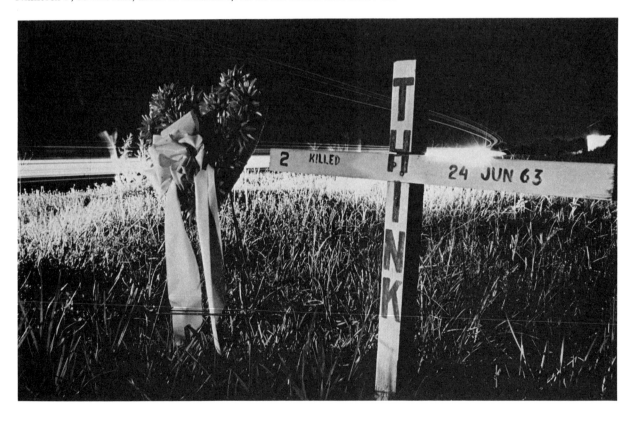

Coming out of the *Times* building at 4 A.M. after working in the darkroom after work hours, I saw workmen using a welding torch to cut through some metal above one entrance door. The sparks streamed down from the hole above the entrance and bounced across the sidewalk.

I set up camera and tripod, used the old reliable eight seconds at *f*/5.6 technique, and produced the picture you see here. The print was used in the

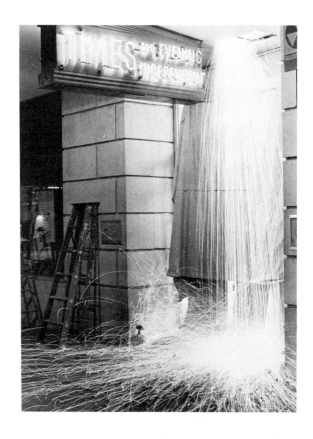

The top picture was made at 4 A.M. after a long night of work. Welders in the ceiling of the *Times* building were cutting through metal and the sparks dropped through a hole and bounced across the sidewalk. Data: Nikkorex F, 50 mm lens, 8 seconds at *f*/5.6 on Tri-X film. The grand opening of a new civic center brought out the searchlights—and the urge to make a nighttime exposure of the building and lights (below). Data: Nikkorex F, 50 mm lens, one-half second at *f*/2.8 on Tri-X film.

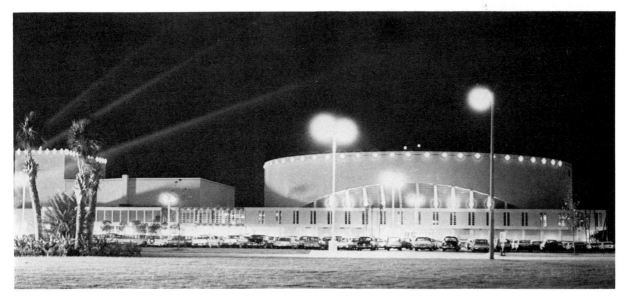

company house organ, and was seen by very upper echelon editors. It certainly doesn't hurt to be recognized.

The other picture was taken the night a huge new civic auditorium opened in St. Petersburg. The fulltime, regular *Times* photographers had made the daylight pictures that would be used in the paper. But I was fascinated by the three spotlights that sliced through the night sky, so I drove to Bayfront Center.

I watched the spotlights swing back and forth and began to catch the rhythm. After awhile it became obvious that every so often all three could appear in my picture. I wanted to catch them as they reached the end of one swing and began the turn back for another sweep. I can't recall the exact exposure, but it was about one-half second at about $f/2.8$.

The picture so impressed our photo editor at the time that he had it used the following day in our afternoon sister newspaper.

Other subjects for night pictures could include the last picture you take in the "day in the life of" type stories, travel features, or perhaps a photo essay on the night people mentioned earlier?

If you're lucky, or can wait, your pictures will be improved by rain or fog. These two elements create glistening highlights in your pictures. Fog adds the feeling of mystery.

A fashion photographer on assignment in Paris once had an entire city block watered down before he would take his picture of a model against the night.

Another detail to be aware of is the silhouette. It may be possible to create a storytelling picture in which one main element is silhouetted against a strong light source or lighted area. This technique works well with woods fires at night, when equipment and men may be silhouetted against flames.

There are many ways to tackle the problem of creating pictures from blackness, but the most basic is the time exposure. Learn it well. Stay out of high crime areas, and have fun learning.

17
Tracing Fireworks

If 1976 could be summed up photographically, it would be called The Year of the Fireworks. All across the nation, both big and small communities set off fireworks to celebrate the nation's Bicentennial.

As a photographer, you'll be called on each year to bring back the beauty of fireworks, usually in black-and-white. Fortunately, few subjects are as abstractly beautiful as fireworks. And few are as easy to capture on film, once such basics as exposure are known.

You'll need no special equipment to picture fireworks. The basics, which you should already own, are a camera with a time exposure or "B" setting, a sturdy tripod, and a cable release.

All-purpose Tri-X black-and-white film will do just fine for fireworks pictures. If your job is to be in color, then choose between Ektachrome X and High Speed Ektachrome.

Since fireworks pictures will be in black and white, I'll give exposures for that medium. To shoot color, you modify exposures by three *f*-stops for Ektachrome-X, two for High Speed normally processed, or none for special processing done by Kodak.

You won't need a shutter speed in shooting pictures of fireworks. Fireworks trace a light pattern against the black night sky and what you want to do is time expose the entire burst. So, camera loaded, mounted on a tripod and ready with cable release, set your shutter speed to "T" or "B."

Fireworks vary in intensity, but since black-and-white film has a great exposure latitude, you can safely compromise an *f*-stop. After years of shooting fireworks, I've settled on *f*/11 as the best bet for Tri-X. Some bursts will be slightly overexposed, some slightly underexposed, but most are right on target.

Fireworks also vary in the height at which they explode. If you are shooting with a 50 mm lens on your 35 mm camera, then perhaps the altitude of the burst will be of little concern. Your lens will cover enough sky to assure the burst will be somewhere in your picture. But I prefer a moderate telephoto lens, 105 mm or 135 mm, and that calls for more precise alignment of the burst within a confined area of sky.

With studied concentration, you can follow some fireworks from the time they leave the ground to the height of their flight. All fireworks come to a stop at their aerial peak before exploding; a valuable fact to know. This will allow you time to stop following the rocketing firework and steady your tripod for the exposure.

You should open the shutter for time exposure a moment before the burst occurs. Wait until the burst has completed its aerial tracing, and then

The City of Sarasota sparkles on Sarasota Bay in this view photographed from 26 stories high. Data: Nikon F, 35 mm lens, about eight seconds at *f*/8 on Tri-X film.

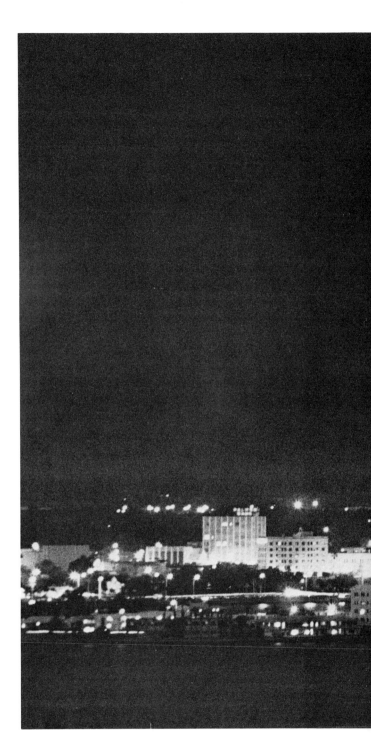

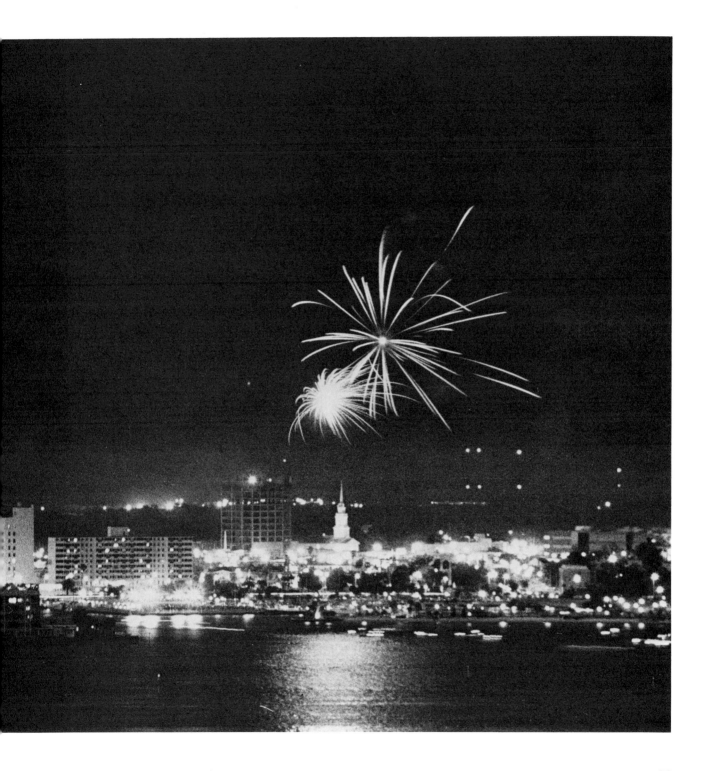

These close-ups of exploding fireworks were made by following the fireworks from the ground. As each pitched over at the peak of the flight, the camera's shutter was opened on time exposure. Each picture was unpredictable since the mirror flipping upward blocked out the view of the explosion. Data: Nikon F, 135 mm lens, exposure for duration of single burst at f/11 on Tri-X film.

close the shutter and advance the film.

Sometimes attractive, but unpredictable results can be had by leaving the shutter open for a series of bursts. Since the night sky reflects no light and does not record on your film, you can record any number of bursts before releasing the shutter to complete the exposure. But if the bursts overlap, the picture will be unattractive. The best multiple shots are those which depict bursts of exploding fireworks side by side.

If you're shooting fireworks pictures for the first time, chances are you'll be sufficiently thrilled just capturing the beauty on film. But if fireworks are somewhat old hat, you need to try a few new tricks to recapture your excitement.

Try multiple exposures involving fireworks and people. Work at placing the burst in the upper-right-hand corner of your negative. If your camera will double expose, then cock the shutter trigger without advancing the film

and prepare for your next exposure. If your camera does not have provisions for multiple exposures, then cup your hands over the lens between exposures. (Your second exposure will be by strobe.)

Place a small child's face in the lower-left-hand corner of your negative. Have the child looking up, toward the upper right corner where the fireworks burst has already been recorded on the same negative. (I hope, needless to say, you are doing all this in the dark of night. Light will expose everything and ruin the effect.)

Now uncup the lens and fire a strobe held high above and to the right of the child. Aim it directly at the child's face. If your strobe is powerful and your camera is still set at f/11, you should put about a double thickness of handker-chiefs over the strobe face to cut the intensity of the light to about f/11.

If your camera can double expose, you have only to frame the picture and fire a second shot at the approximate exposure—perhaps 1/60 sec. at f/22.

If you find all this too complex to attempt in the camera, then do it in the darkroom. One year a fireworks display I photographed was accompanied by a fierce electrical storm, with lightning snapping behind the bursts. But none of my pictures captured what the audience there had seen. To be on the safe side, I had taken separate pictures of lightning and fireworks.

I put the two together in the dark-room. I exposed the fireworks on the upper-right section of the sheet of print-ing paper, while holding back any expo-

"4th" is traced onto film using the light of a sparkler. The tracing was done with the camera set on time exposure, then the model was positioned and a single burst of strobe captured her image. Data: Nikon F, 28 mm lens, about 15 seconds at f/11 on Tri-X film with strobe fill.

sure in the lower left. Then I inserted the lightning negative, framed it on the paper by using a red filter over the enlarger lens (which prevents any exposure on the paper but allows you to see the projected image), removed the red filter, and exposed the lightning while holding back any exposure in the area of the fireworks. The final picture, a visual lie, was nevertheless an accurate representation of what the crowd had seen.

The vantage point from which you shoot fireworks is all-important. Most photographers will shoot from a position almost directly beneath the bursts. This is the best angle for producing the classic image we have of fireworks, and is also faithful to the view of the spectators.

But an entirely different type of picture can be obtained by shooting from miles away atop a skyscraper or very tall building. With proper lens selection, you can picture your city's skyline capped by fireworks. Leave the shutter open about 20 seconds to record a variety of lights in buildings below the fireworks. Multiple-burst pictures are also attractive in this setting.

There's another type of pyrotechnic device much preferred by the smaller set: sparklers. Like fireworks, sparklers trace a time-exposed pattern. Unlike fireworks, the pattern can be controlled.

A few years back, I used such a controlled pattern to spell out Happy 4th. The *f*/stop was set at 11, the shutter on time. I had a piece of black cardboard handy to block out the tracing at any time I desired. For this particular shot, I used two other persons; a model and a cardboard-holder.

The camera shutter was opened while the cardboard was held over the front of the lens. I lit a sparkler, walked to a predetermined spot, yelled back to remove the cardboard, and began writing with the light.

When I finished "4th," I ordered the cardboard back over the lens, handed the sparkler to the young girl model, and returned to the camera. She held the sparkler high over her head as I triggered a strobe to expose her and closed down the shutter.

This technique is called "open flash." This type of picture can only be made at night, of course, and preferably without any light visible in the background.

In making pictures of fireworks and sparklers any camera can be used, but this is one of those situations where the twin-lens reflex excels. I use a Minolta Autocord that has served faithfully.

The twin lens allows continuous viewing of the subject while taking the picture. With a single-lens reflex camera, the subject is blacked out as the mirror flips up to make the exposure. The twin lens lets you follow the sparkler writing as it is done, see the complete fireworks burst, and sketch the fireworks burst on the ground glass with red crayon so a child may be placed on the negative without an overlap.

18

Posing
the Model

Meet Allyson Jill Shuler. Call her Jill. At this moment in history, she is no one special. She's just a 16-year-old, 5-foot, 6-inch tall, 115-pound adolescent who lives in Florida. But she's perfect for a chapter on posing the model for two reasons: (1) She has neither posed before nor taken any modeling courses; (2) She's my wife's younger sister.

Sooner or later in your photo career, you'll be faced with the need to direct and pose a female model. Most likely you'll be asked to photograph a beauty queen. Many newspapers also feature a beauty-of-the-week picture, and it may become your lucky chore to participate.

I must confess that many such weekly offerings are poor indeed, and in most cases I fault the photographer for not doing his job. Most average girls can be made attractive with proper posing.

I'm not going to show you a bad picture of Jill. That's part of a promise I make to every model I photograph. But I will assure you that, hard as it may be to believe, Jill is simply an average high-school student. She can easily be photographed unattractively. Beauty or glamor photography takes effort.

All but two of the pictures of Jill were made in a single afternoon session in which 150 negatives were exposed. Let's talk about what goes into posing a model.

There are only four types of composition—horizontal, vertical, diagonal, and curving. There are only

three basic stances for the body, called: S, C, and I. And there are only three basic positions for these stances: standing, seated, or lying. But within these limits are thousands of possibilities for pictures.

Let's discuss each type in detail. Horizontal compositions are restful and solid. Vertical ones are dignified.

Diagonal pictures denote action and are unstable. And curving compositions are usually soft, gentle, and rhythmic.

The three basic body stances are achieved by considering the positions of the lead leg, the torso, and the head. If the lead leg (the one closest to the camera) is pointed right, the torso straight, and the head tilted left, then you have

This posture is somewhat strained, but you'd never know it from the happy expression on the model's face. The pose was carefully set up, and at the last moment the model was told to pull out her hair gently with her left hand. Data: Nikon F, 20 mm lens, 1/1000 sec. at f/8 on Tri-X film.

an S stance. If both leg and head tilt the same way, you have a C stance. If the body, head, and legs are straight, you have an I stance.

The way you use these stances affects the discomfort or ease which the model will feel. A standing pose is the most difficult to assume attractively. I do it last in any model session. The easiest to use is the S-lying position. This is most relaxing and natural for the model.

Since Jill was new to modeling, I began with prone and supine positions. Jill has no "problem" body area, but if she had a bulging stomach, I could have hidden it quite effectively in a prone C stance I used with the dramatic sky-beach background. In this picture, I wanted a teenage ingenue effect, so I used oversized sunglasses and a very relaxed posture (coupled with the restful horizontal composition of the picture).

While I'm talking about using poses to hide anatomical defects, consider the seated posture. The model sits back on one or both feet, and in the process hides fat thighs. Her arms can be placed to hide stomach rolls. Jill doesn't have these problems, but many girls do.

The standing posture shows everything, but especially emphasizes legs. If your model has shapely legs, shoot from low and behind her, with her head thrown back so she looks over her shoulder. A toe-rise completes this posture.

But to return for a moment to the lying positions, for the full-length supine picture shot from almost directly overhead, I used an extreme wide-angle lens and stood two feet from the model. Since Jill had not posed before, every part of her body had to be directed into position. Her hair was carefully arranged, her leg fanned (a concession to modesty that dates back decades), and her hands placed down her sides. The result is a powerfully attractive picture. The location is a seawall with cattails on one side and a rock garden on the other.

Another horizontal composition was taken along that same seawall, this time with the 20 mm lens close to the model to create a distortion popularized by Art Kane in fashion photography. I first positioned Jill, then asked her to throw her head back to the sun and use one hand to pull out her hair slightly. This type of pose is called a lying-S position.

I shot another portrait of Jill stretched out prone on the seawall. I crouched low and shot from the end of the seawall after positioning her with chin on her hands.

Other pictures were taken at a beach. In the shot against the sun, she holds a modified S stance with her rear leg making small circles in the water. Such a standing posture will display every defect in a girl however, and cannot be used for every model.

With her bikini still on, she went to

the shore and I asked her to jump several times. Frontal jumps always make a model appear to be a double amputee, so stick with side views. The hardest part here for Jill and all new models is maintaining a pleasant facial expression while straining during the jump. This is a strong C action stance.

For the final picture of the day, as the sun sank, I had Jill don her jumpsuit and wade in the tidal waters. She was asked to kick water gently past my camera, and the picture that resulted exemplified a sharply modified S stance.

Now that you've examined the pictures, let's consider some other facets of model photography. How do you direct a pose? I suggest you memorize at least ten basic poses. Use this chapter and the one on the beauty queen if you like anything you see here. If you don't, then clip poses from magazines and save them for reference on your next glamor assignment.

Learn to direct a neophyte into your ten basic poses. In setting each individual pose, begin with the feet and legs. If you need to express a position to a model, ask her to imagine a clock at the base of her feet, with 12 pointing toward the photographer. Then ask her to point her left foot to 12 and her right foot, behind her left, to 2. You will use this clock system for each standing pose thereafter.

When the feet and legs are set, then set the twist of the torso. Usually you will employ some twist, perhaps to minimize large hips or broad shoulders. By twisting hips and shoulders at angles to the camera, they will appear smaller in the two-dimensional print. This is important for standing poses.

After the torso twist is set, then position the hands. There are hand stops, as they're called, available in the hair, and at the neckline or collar, the shoulders, waist, hips, and thighs. Any combination can be used. A model usually feels uneasy about her hands. Help her by directing their positions.

Now set the tilt of her head, both sideways and up and down.

Your final chore is the facial expression. I don't care how good a model's body may appear, an ugly face or unpleasant expression will ruin the picture. The camera shouldn't click until that facial expression is pleasant.

Encouraging pleasant expressions is largely a matter of relating to the model. You should flatter her with honest compliments. In Jill's case, this is easy since she has many of the same

The top left photo was a "test picture." The model was asked to try a jump, while holding a smile during the jump. Although this photo was snapped when the model thought no picture was being taken, it turned out to be the best jump shot of the day. The Gulf of Mexico formed a placid pool for the model to trace patterns in the water with her toes in the photo on the upper right. The setting sun created the sparkles on the water behind her and to her side. Data for both: Minolta Autocord, 1/500 sec. at f/8 with strobe fill on Tri-X film. The bottom pose makes the model a teenage ingenue, cute and aloof. Experiment with one leg up, both legs up, both legs down, etc., when posing a model. Data: Nikonos with 35 mm lens, 1/500 sec. at f/11 on Tri-X film.

attributes that attracted me to her sister, my wife. With sufficient flattery and encouragement, the model develops a positive attitude that results in even better pictures for which you can issue still more praise.

Remember, she's doing the work; you're just pushing a button. Show her you care, and be patient.

Now with her body positioned, you should encircle the model, shooting all the while. Then shoot from both high and low angles. Shoot, shoot, shoot.

A modeling session is an emotional "high" for both model and photographer. If you shoot a lot, you will avoid having to tell a pretty girl you didn't get anything either of you would like.

Nearly all of the pictures here are of one model attired in a bikini. But glamor photography can involve other items of clothing. You should match the clothing with the model. If the girl has a small bust and perhaps a stomach bulge, but great legs, then put her in a baggy sweater that comes just low enough to cover bikini bottoms. Shoot from behind.

A girl with pudgy legs but a large attractive bust can be photographed in tight Levi's and a halter top or a T-shirt top.

High heels add needed height to short legs. A pair of sunglasses can hide unattractive eyes or eyebrows. When pulled down playfully on the nose, they can hide a nose that is too big or is humped. Pushed up, they can hide a hairline that recedes a bit too far.

Hats can hide a lot. But the invention of wigs and falls was the biggest boon to models and photographers. In one afternoon there wasn't time to do this, but imagine Jill as a brunette with kinky curls. It's easy with wigs.

While I'm talking about adding things . . . I have each model wear a bikini (white if they have it), and ask them to bring along shorts, shirts, sweater, Levi's, and skirts. Then they progressively add clothes as I shoot. (Don't try to reverse this. They may be modest about the idea of progressively stripping.)

Dancers make the best models, with cheerleaders a close second in my book. The best ages are between 15 and 20. Remember the face comes first. Find that face, connected to a good body, and take your model to the beach, a pool, the woods, a field, a studio.

Memorize those ten basic poses you like. Think in terms of movements the model can do. Help her. Praise her. Do your part to make the session successful. If these basic suggestions were followed, there'd be no excuse for so many of the unattractive glamor pictures that adorn many newspapers and embarrass the pictured subjects.

19
The Picture Story

If you want more than one picture of any given shooting assignment in your newspaper, then you have only two routes to take: the picture story or the picture essay.

Many photographers and books make no distinction between the two—and indeed they are similar—but I think of the old *Life* magazine as synonymous with the picture story and the old *Look* magazine as the epitome of the picture essay.

When *Look* wanted a story on California, the editors assigned Art Kane or Pete Turner to produce an essay, leaving the choice of subject matter to the photographer. When *Life* wanted a California story, it zeroed in on one family that typified the life-style and carefully instructed its photographer to "get under their skin."

Of the two approaches, by far the most frequently used by newspapers is the picture story. And often the best multi-picture layouts produced by a photographer result from assignments to get under someone's skin.

Such was the case with Miss Manatee. Every small burg in the United States has a Miss Something contest, and your burg is probably little different from my burg. In mine we celebrate the Miss Manatee Pageant.

Chances are that unless you give the matter some thought, you end up sending a photographer to cover the pageant, run a picture of the winner with her mouth open in surprise, and

then perhaps follow up with a family picture a day or two later—in the women's section, of course.

I wanted to do something different the year I took on the Miss Manatee Pageant. I wanted to spend the day with the winner, experience the buildup of tension with her, and find out what goes on in the hours before the stagelights go on.

My coverage began with the dress rehearsal, a day before the pageant. I went without camera and sat in the audience with the sponsoring club members, getting a clue as to their idea of who might win. From thirteen entrants, only two appeared to have a chance at the title. I picked one.

Her name was Jennifer Jester.

I'm not sure what possessed me to go up to her and ask to spend the next day with her, but somehow I did it. She didn't bat an eyelash before she said yes.

I had no idea who she was, how personable she might be, where she lived, what her family might be like—but it all worked out. I handed her a business card to show I meant business, and she scribbled an address on the back. She said her day would begin early— swimming before a hair appointment at midday, followed by non-stop preparation for the beauty pageant.

The next day I showed up at a lovely home in a fine area of our community. In the yard was a gorgeous swimming pool. I would begin there.

Yes, she had swimming suits—lots of them. In all, I recall having photographed four that morning. I began our session with poolside shots in a yellow bikini, followed by some inner-tube shots in a more conservative one-piece outfit.

Then it was time to get the hair wet, and I asked her to repeatedly toss her head backwards, flinging water droplets over and above her. After that it was underwater for the final pictures of the swimming session.

The view on the left provided a different perspective of a pretty girl. The picture was taken from the side of a swimming pool with a moderate telephoto lens. The beach balls at the top floated freely into the picture and proved so attractive the photographer altered his planned composition to include them. Data: Nikkorex F, 135 mm lens, 1/1000 sec. at f/5.6 on Tri-X film. Many years ago, a Nikon ad featured a girl tossing her wet hair in this fashion (right). The picture here was made by existing sunlight in the pool at Jennifer Jester's home. Data: Nikkorex F, 50 mm lens, 1/1000 sec. at f/11 on Tri-X film. After the surface pictures were made, it was time for underwater experimentation. This striking picture below resulted, proving that pretty girls are photogenic in any environment. Data: Nikonos with 35 mm lens, 1/500 sec. at f/8 on Tri-X film.

Her family was very nice, and her sister even took a picture of me taking a picture of Jennifer. I still have a copy—that displays my skinny torso outfitted in swim fins and face mask. Beauty and the beastly photographer.

I talked with her family as Jennifer showered and prepared for her hair appointment. On this assignment, I was both reporter and photographer, so much of my time was spent interviewing those who knew the potential Miss Manatee well.

We rode in her open sports car to the downtown beauty salon, and I used that occasion to snap tight head shots as her hair blew in the wind.

The beauty parlor provided some outstanding shots of a pert, cute girl undergoing the American woman's ritual. Of the more than 100 pictures I took this day, two of the beauty parlor ultimately made the final layout.

An assignment such as this provides me with a convenient excuse to be places I couldn't or wouldn't normally be, as in the case of this beauty salon where there were marvelous picture possibilities!

And it provided Jennifer with an ego boost. After all, she had a personal photographer everywhere she went.

The final hours of the afternoon she spent putting on makeup before a small mirror in her bedroom. We talked about tricks beauty queens use before pageants: using Visine in the eyes to create sparkle, putting Vaseline on

Beauty and the boots in a beauty parlor prior to the Miss Manatee Pageant. The only lighting was overhead fluorescent lights. Data: Nikkorex F, 35 mm lens, 1/60 sec. at f/4 on Tri-X film.

A few hours before the beauty pageant, Jennifer applies eye makeup at her home. The only light was provided by the bulbs on the makeup mirror. Data: Nikkorex F, 50 mm lens, 1/20 sec. at f/2 on Tri-X film.

their teeth to create a glint from the spotlight when they smile, using a quick-tan lotion around their buttocks to eliminate any white skin that might show in the bathing suit competition.

It was a new world to me.

The pageant itself went well. It's much easier to follow one girl with a camera than to try to cover them all, hoping you come up with a good picture of the winner. Should Jennifer lose, I concluded, I would still do the story as the effort of a loser. I would use one picture of another girl being crowned.

Jennifer won.

The first vote ended in a tie between the two girls I had thought had a shot at the title, and a second ballot was needed to break the tie.

Do I need to say I was almost as happy as Jennifer? That day began a year long friendship during which I photographed her numerous times, mostly in color.

And at the end of the year, when she walked down the aisle for her final applause, behind her, 25 feet tall by about 55 feet wide, were 20 color slides I had shot over the year. The auditorium was darkened. One spotlight followed Jennifer on her walk, and a projector at the rear of the 900-seat auditorium threw the 35 mm transparencies onto a stage screen.

To my disbelief, my name was announced as having shot the pictures and both Jennifer and I got a standing ovation. It was a moment to cherish. And it all began with a "day in the life of" story on a girl aspiring to a title.

20

Mug Shots or Portraits?

They're derogatorily called mug shots. People heads. Portraits on the run. Almost every paper, almost every day, runs mug shots of celebrities, the locally prominent, the newly in-the-news.

A mug shot can be a poor excuse for a picture, a space filler, a page balancer, or it can be a small exercise in photographic excellence. The choice is yours. As an editor, I won't sit still for a photographer explaining to me how his mug shot isn't very good. The point is, it doesn't have to be bad.

The mug shot is the photographic equivalent of television's "talking head." TV considers this type of pictorial information as the worst possible, better only than no picture at all. But that's not always true with newspapers. Newspapers are basically printed-word media, and our mug shots should convey needed pictorial information or perhaps they are better left out of the paper.

People are interested in people. We know that the mug shot has a place of interest with readers. Instead of belittling it as a photograph, let's work to improve it.

First, let's keep the mug shot up-to-date. If one county commissioner or city councilman is in the news day after day, then you bore readers by reprinting the same mug shot each day. Go after a new one regularly. Use the assigned photographer to capture mug shots of all officials involved each time he is assigned duty at a meeting. Keep them

coming fresh week after week to build up your file.

My personal preference is for tight mug shots that fill the frame with the head of the person. Exclude surroundings and all extraneous matter and concentrate on the facial expression.

It helps to know your subject because then you begin to recognize gestures that are truly characteristic of that person. It helps because one expression may truly say something universal about that person.

When I speak of expression in a mug shot, this is similar to mood in any other photograph. Good writers try to make their writing, their sentence structure and word use, fit the tone or mood of the story. A quick burst of action would be written with short, choppy sentences filled with action verbs. A drawn-out statement could be told with a long sentence containing a passive or weak verb.

Photographers must also create a mood—even with the lowly mug shot. If the person is mad, and that anger highlights an event, then the picture should reflect seriousness or anger. Ditto for sadness, happiness, and the other emotions. Not reflecting the true emotion is a more subjective choice than truly reflecting it. I feel similarly about the word "said." Sure, it's very objective, but it takes a lot of modifiers to convey the sadness that would be conveyed by the verb "sobbed," the anger by the verb "shouted," the shortness by the verb "blurted." I have a list of about 200 choice action verbs that relate information much better than "said." Your photographic language should contain these same tools.

Generally, a dark portrait is serious, sinister, threatening. A light portrait is happy, airy, humorous. Match tone with mood as expressed by facial expression.

By now, you've gathered the key to a good mug shot is the facial expression. Your ability to catch that fleeting expression will challenge you as a photographer. It's every bit as demanding as sports photography. It's just a different type of "decisive moment."

Consider the widely-known individuals pictured here. Each portrait, or mug shot, reflects my attitude toward the individual and hopefully addresses the true character of the person.

President Ford is pictured with his head thrown back, a posture of authority. His gaze is distant, not directed at the viewer. He is inaccessible in this picture. I view the Presidency that way.

Challenger Ronald Reagan is pictured with the trappings of the campaign around him. I waited until his expression and posture nearly matched that of the picture to his right, and then image snapped—and caught the man and his Hollywood image. It's not really a mug shot in the true sense, but it does reflect my idea of a Reagan portrait.

Henry "Scoop" Jackson promoted himself as a man of honesty. His glance

Gerald Ford, as President, arrived at the Sarasota-Bradenton Airport at night and immediately stepped to within six feet of the press for a conference and photo session. More than 75 photographers from national and local media were jammed behind ropes as he spoke. Data: Nikon F with motor drive, 135 mm lens, 1/60 sec. at f/11 with strobe on Tri-X film.

This picture was composed to capture the hoopla of the Ronald Reagan campaign. The scene was inside a shopping mall and the light was almost nonexistent. Rather than try for a tight close-up of Reagan, the photographer chose to compose the candidate and his image—waiting for a moment in which Reagan's real expression matched his photographed image to his right. Data: Nikon F, 200 mm lens, 1/250 sec. at f/4, developed in special formula with Tri-X film rated at ASA 4000.

117

Senator Henry "Scoop" Jackson likes to look voters straight in the eye—and is quick to spot a camera (left). When Jackson campaigned, he would make sweeping hand gestures. It soon became obvious that he was shrewdly offering each photographer a head-on shot of his gesture and face. Data: Nikon F, 135 mm lens, 1/1000 sec. at f/8 on Tri-X film. A wheelchair-bound George Wallace on the campaign trail in 1976, typically exorting the crowds (right). Of many exposures made of Wallace, perhaps this best captures the fiery little campaigner. Data: Nikon F with motor drive, 200 mm lens, 1/2000 sec at f/8 on Tri-X film.

would then have to be direct, head-on. In my mug shot of him, it is. I captured him characteristically narrowing one eye as he made a point. This mug shot is every inch "the candidate."

George Wallace is a gutsy fighter, a pent-up bundle of anger spitting out at the world. He works a crowd. He needs a microphone and this picture has one. His hand slams home each point of his oft-repeated platform. I have many mug shots that are portraits of George Wallace. To me, this *is* George Wallace.

I feel equally at home with the portrait of "Smokin' Joe" Frazier, ex-heavyweight champion. Joe comes at

his opponents with his head down, a posture reflected in this picture. And it seems that Joe has lost more big fights than he's won. So the downcast head takes on a psychological value. The sweat completes the mug, symbolizing the physical struggle of his chosen vocation.

Johnny Bench, perhaps the best catcher to ever play baseball, is a clown. He showed up for a television appearance wearing a T-shirt emblazoned with his likeness and signature. Capturing this mug shot was a matter of waiting for his head to tilt back at the same angle as the one on his shirt.

Heavyweight boxer Joe Frazier was captured on film a bit downcast after an exhausting run in the Superstars competition held several times each year in Rotunda, Florida (left). The expression seemed to fit the man who was always among the best in the boxing world—but never could stay on top. Data: Nikon F with motor, 80–200 mm Nikkor zoom lens, 1/1000 sec. at f/8 on Tri-X film. Johnny Bench of the Cincinnati Reds baseball team is quite a clown (right). He showed up at a Superstars competition wearing a shirt with his portrait and signature. Bench was telling a humorous story when this picture was snapped, composed to show both the real man and his T-shirt image. Data: Nikon F with motor drive, 80–200 mm Nikkor zoom lens, 1/1000 sec. at f/8 on Tri-X film.

The dark portrait of Miami Dolphin super kicker, Garo Yepremiam, was made at a bank dedication. It was outdoors and the black background is really just deep shadow. I shot from the front row with a 200 mm lens as he stood at a podium.

For nearly all mug shots, you will use a lens between 105 mm and 200 mm. Most of the time, I use a 135 mm, although I have some striking portraits done at close range with an 80-200 mm Nikkor zoom.

If you want a very tight shot (not always recommended), then put an M-ring on your camera before you attach your 200 mm or 300 mm lens. Your focusing range is extended to very close quarters with this addition. You can also use lens extenders behind a lens to double its focal length, or magnifying filters in front of a lens.

Compose tightly. Eliminate the podium in all but one overall shot that shows the crowd and the speaker. And then concentrate all of your effort in capturing the elusive expression that best illustrates the man or woman you are photographing.

I think of the mug shot as a photo-journalistic portrait. At its best, it's as good as any portrait by any artist. This type of portraiture on the run, may be recorded in history as modern art.

Garo Yepremium, the soccer-style football kicker of the Miami Dolphins, is pictured at a bank dedication. Yes, that's where this picture was taken. The scene was outdoors, the light contrasty and the background in shadow. Data: Nikon F, 200 mm lens, 1/1000 sec. at f/16 on Tri-X film.

21

Aerials

As editors, we know that readers take our newspapers to learn of happenings that occurred at a time or place that they could not attend firsthand. As photographers, we should know that the pictures that often impress viewers the most are those taken from a vantage point unique to the viewer.

Consider aerial photography.

Few readers have the luxury of unlimited aircraft travel, and most of them thrill to aerial pictures. One of the most common nightmares of childhood is falling through space, and a picture that doesn't contain a reference point—such as an airplane wing—renews that scary feeling that viewers love as adults.

Let's discuss how to make aerial pictures, the problems you will encounter, and the instances when an aerial shows a scene better than a photograph from any ground angle.

Basically, you have two choices of craft for aerial photography, a small airplane or a helicopter. Since most newspapers operate on limited budgets, I'll bet that most of your pictures will be made from a single-engine airplane, perhaps with the door removed. To me, such a ride is always wild and risky. I get nervous just thinking about it.

The only benefit of the airplane over the helicopter is cost. If you can afford it, a helicopter is a superior beast for the photographer. It is far more versatile in its ability to quickly find the best angle for the picture, to hover in one spot, to land anywhere.

There is one other type of aircraft that I really enjoy—a blimp. I've used one twice for pictures, and each time was an enjoyable experience. Goodyear operates the only remaining blimp service in this country (although blimps may make a comeback as a commercial carrier). And while your town surely won't be headquarters for a blimp, the Goodyear blimp may visit during festivals or celebrations. If you get a chance, climb aboard.

I took some night aerial pictures from the Goodyear blimp in St. Petersburg while it drifted with the wind, engines shut down. The exposures were made at 1/30 and 1/15 sec., hand-held, with a normal lens. No other aircraft can shut down to eliminate engine vibration.

My ride began at twilight, and I from the Gulf of Mexico. Then a sprinkling of lights lit the early evening, giving a feeling of night, while good detail still remained visible on the ground.

Finally darkness came, and I used those slow shutter speeds to provide our viewers with unique views of car lots, downtown buildings, and ballfields. The pilot said this was only the second time his blimp had been used for night photography. The trip was an incredibly beautiful four-hour drift-flight in a magnificent craft.

Since you probably won't use a blimp more than once or twice in your lifetime, let's talk about renting an airplane. It'll cost you about $20 an hour for one seat on a small airplane; about $80 an hour for a helicopter.

You'll phone the flight service and reserve a plane for a specific time. Should you need a plane for a spot-news photograph, in most cases you'll have no trouble getting one immediately.

Ask for a plane with an above-fuselage wing. Tell the service the charter is for aerial pictures and you'd like the passenger door removed if possible. Then you're ready.

Almost any camera will do, but the larger the negative, the better you can enlarge the ground image. And you won't enjoy looking through a telephoto lens as the plane bounces around in warm and cold air currents.

All things considered, I like a 2¼″ negative for press aerial work. If you're working in color, or a large area needs to be enlarged, then use a 4 × 5 camera. The pros use anything from 8 × 10 to 11 × 14 and bigger.

Now you know how to charter an airplane, what it will cost, and what camera to take along. When do you need aerial pictures?

Almost any large ground subject can be shown well in an aerial photograph. But since airplanes are expensive to charter, I suggest you save up assignments until you have about six to ten needed pictures. Then get the airplane, show the pilot the areas you need to cover, pop two Dramamine tablets into your mouth, and you're ready.

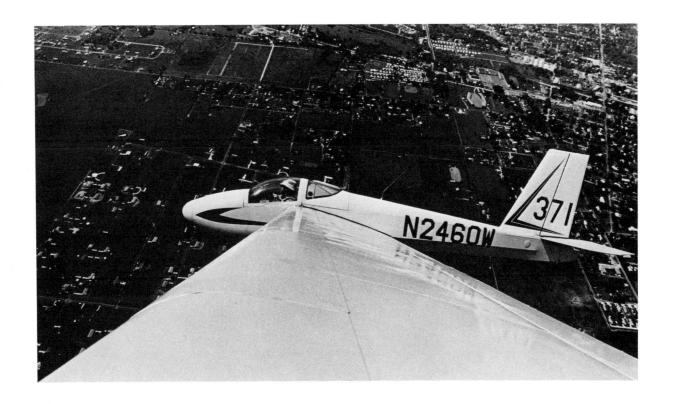

A motorized Nikon F camera with an extreme wide-angle
lens was attached to the wingtip of a glider. An electrical
cord was trailed beneath the wing and into the cockpit
where the pilot could trigger exposures by pressing a
doorbell switch attached to the electrical cord. Data: Nikon
F with motor drive, 20 mm lens, 1/2000 sec. at f/8 on Tri-X
film. Photo by Dick Dickinson.

This just *looks* like a picture of the entire earth spread out beneath the gondola of a hot air balloon. In reality, a fisheye lens was used on a camera attached to a bar across the top of the gondola. The cord used to trigger the camera is visible on the left. Data: Nikon F with motor drive, 8 mm fisheye lens, 1/500 sec. at f/8 on Tri-X film.

124

The mention of Dramamine isn't entirely a joke. These tablets control motion sickness and are widely used by travelers. One of the best known aerial photographers is John Zimmerman, who becomes ill almost every time he flies. Dramamine decreases the chance you'll need an air bag.

I've flown in everything from small plane to commercial jet, from helicopter to blimp, and still get extremely nervous before and during a flight. I always use Dramamine. Believe me, your system will let you know if you need it.

Once you're in the air, tell the pilot to keep the altitude to the minimum federal requirements—1000 feet over populated areas and 500 feet over rural ones. All of your picture taking for newspapers will be from that level. Mapmakers work higher; you don't need to.

If you can choose the time of day to fly, then work at about 10 A.M. or 2 P.M. These hours present the best shadow play on the ground. High noon is awful. Late evening and early morning shadows are too dark and dominant.

The first problem you'll face as an airborne photographer is the setting of your camera. If you're using Tri-X film, you can use a normal, daylight setting of 1/1000 at *f*/11. Use the maximum shutter speed available on your camera to overcome vibrations from the airplane's engine and the bobbing motion of the aircraft in flight. And don't rest your camera lens or any other part on any part of the airplane. The vibrations can ruin the picture.

Hold the camera in your hands, using your arms as gyroscopes to maintain a level horizon. "Squeeze off" each exposure as carefully as you can. No need for "grabshooting" up here.

One problem you may run into right away is pollution, politely called haze. If you're shooting in color, this tints each picture blue. If you're working in black and white, the overall contrast of the picture is reduced and sharpness is diminished.

With color film use a UV filter. With black-and-white film, contrast can be improved and the blues washed out with a light yellow filter. It's safe to always use a light yellow for aerial black-and-white photography, even when the haze seems inconsequential to you.

Aerial pictures are particularly effective in showing relative locations of ground objects, such as a new shopping center near another locally known landmark. They are excellent for spot news not easily shown at ground level, such as a major accident or fire. They provide a new perspective for local festivals or parades. They are valuable historically to show the changes of a coastline, or development of an area.

An aerial picture may be improved by superimposing the names of local streets, businesses, or landmarks over the print. Direction (N) may be added also, as may scale. As with all pictures we present to the readers, the object is to

clearly communicate. Art may help this communication process.

Whether your paper uses cold type or hot type, the technique is the same for art used over an aerial. Set the information in type, print that type, and then paste up the information on the print prior to engraving the print.

One final word on how I use aerial pictures at the *Manatee Times*. Every time a hurricane threatens our section of Florida, I send a photographer airborne to photograph every mile of coastline. Then, should disaster strike, I send the photographer airborne again to show "before and after" views of devastated areas.

If disaster bypasses us, I can always use the aerials to show development progress along the coast. And those same aerials will be priceless historical treasures 50 years from now.

As a matter of routine, I "fly" aerials of almost all of my city about once a year. If a tornado strikes, I'm ready with before and after views. But if you get stuck and need an aerial in a hurry for a "before" view, check your county or city engineering department. They usually have current aerials on file.

No matter how you use aerial pictures, it will probably help your paper to raise your photographic sights—about 1000 feet to be exact.

22
Movie-Set Shooting

With more and more movies calling for on-location filming, the odds are good that sooner or later a movie company will come to your area. When it does, you'll want to picture the activities.

The proposition has its share of problems. I ran into them head-on when a grade B flick entitled "Ride in a Pink Car" was filmed in Rubonia, Florida, a migrant housing slum in my county.

The movie producer was more than willing to publicize his movie. But opportunities for still photography on movie sets are limited by considerations that come first for the sound-movie cameras used by the company.

The still photographer will find himself concerned with two primary limitations: noise, of which there can be none, and shooting location, which may not be the best.

If your camera makes a noise audible to the sensitive shotgun microphones used by most movie companies, then you will be denied shooting privileges while a scene is being filmed.

How do you quiet the camera?

First, you may be able to use a camera quiet enough for most movie sets. The noisiest camera you could possibly select is a motor-drive Nikon. Make it last on your list for now.

Perhaps the amphibious Nikonos would be satisfactory. It was fine on the movie set where I shot my stills. A rangefinder Leica is very quiet and was long the favorite of candid photojour-

nalists. Twin-lens reflex cameras such as the Minolta Autocord or the more expensive Rolleiflex models are quiet.

But the problem with most of these cameras is the limited (or lack of) lens selection. To do a creative job, you'll need more than a normal lens. To picture action taking place, you'll need a longer-than-normal lens. To show the overall set, you'll need a wider-than-normal lens. So I stuck mostly with my noisy motor-drive Nikon.

The answer to the noise problem is something called a "blimp." All movie photographers are familiar with the term, which describes a foam rubber device that fits over the camera and muffles the sound. Blimps are extensively used on sound movie cameras, to prevent the sound of the camera's whirring from being recorded on the magnetic tape strip along the film.

Nikon no longer makes a blimp for its motor drive. But you can create a makeshift model with a large pad of foam rubber and some tape. Just leave holes for the front of the lens, the viewfinder, and the camera shutter trigger.

One photographer had a run-in with a professional golfer at a tournament I attended. The golfer became peeved at the sound of the motor-drive Nikon and finally refused to tee off until the photographer stopped shooting.

The photographer disappeared from the golf entourage for awhile, then reappeared with a towel draped around his neck. As he prepared to shoot, he wrapped the towel neatly around the camera several times, his right arm emerging mummy-like from the wad of toweling. But his camera was very quiet when he shot. I'll add as a final note that noise is not a real problem if you shoot from some distance using telephoto lenses.

And that brings me to location.

Obviously (with a good director), the best locations for shooting will go to movie cameras. You'll have to work around them.

Now you may be used to working around television cameramen during spot-news coverage, but a movie camerman is a different matter. To begin with, everything is planned. The lights are just so; the microphone must be properly placed; reflectors are brought in; stagehands stand by.

In a stunt from the movie "Ride In A Pink Car," the car approaches a fruit stand, splashing through a puddle of water left from an early morning rain. A stuntman leaps from the roof of the stand just before impact (top). Data: Nikon F with motor drive, 80–200 mm Nikkor zoom lens, 1/1000 sec. at f/8 on Tri-X film. The stuntman hits the ground as the car slams into the produce, splattering fruit in all directions (center). At about this moment, a large fruit is shattering the windshield of the car and the stuntman-driver has crouched deep into the seat. Data: Nikon F with motor drive, 80–200 mm Nikkor zoom lens, 1/1000 sec. at f/8 on Tri-X film. The roof above the fruit stand collapses as the car knocks down support posts and continues to decimate fruit (bottom). The stunt came off exactly as planned and made exciting film fare. Data: Nikon F with motor drive, 80–200 mm Nikkor zoom lens, 1/1000 sec. at f/8 on Tri-X film.

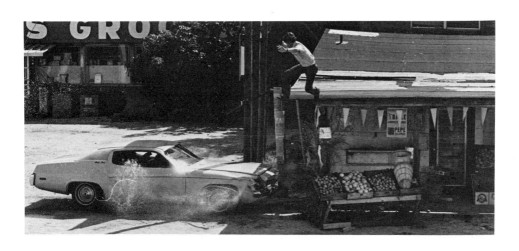

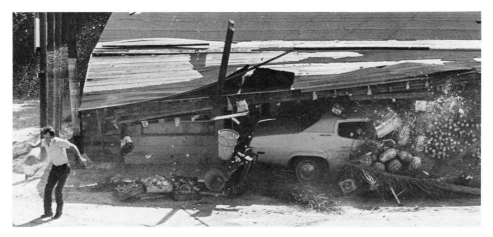

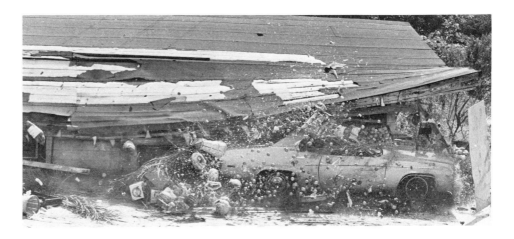

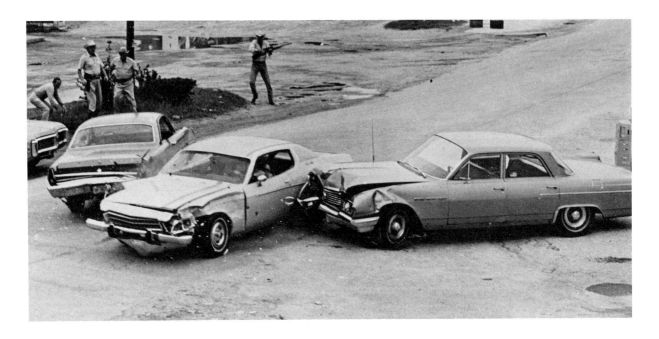

This crash stunt was executed with Pink Car traveling at 80 miles an hour. The idea was for it to crash into the two cars forming a roadblock and send both stationary cars spinning to the side. The stunt fell a bit short when the two parked cars failed to spin away, but alert driving by a stuntman made the trick super spectacular on the screen (he did a 180° turn immediately after crashing the roadblock). Data: Nikkorex F, 200 mm lens, 1/1000 sec. at f/5.6 on Tri-X film.

You must aim your camera through this mess. Chances are good the first few shots you make will contain a boom microphone, or a reflector, or a stagehand in the background. Just keep moving until you find an open spot.

The movie I photographed was an action film highlighted by a car chase that demolished seven vehicles. While the scene takes only minutes on the screen, it took days to film. Each smashup was filmed individually, with stunt men driving the cars on different days. Each required careful setups for both the movie cameramen and myself.

The first scene I handled was a crash that called for Pink Car to smash through a roadblock of two cars across a highway. The scene took place about 7 A.M. after sheriff's deputies (real ones, not movie actors) had blocked off the road. Ambulances stood by. Great gobs of automobile wheel bearing grease were smeared beneath the wheels of the cars crossing the road. The idea was for the two cars to spin violently away after Pink Car struck them.

I mounted a motor-drive Nikon

atop a ladder and leaned the ladder against and behind a telephone pole, to hide the camera from the view of the movie camera. An electrical cord was plugged into the motor drive and trailed off through the window of a nearby building. A person inside was told to trigger the camera as Pink Car approached the roadblock. It would fire at four frames per second.

I took a second camera and climbed atop a roof farther down the street. From there, a 200 mm lens gave a good view of the roadblock. The ladder-mounted camera had a 20 mm lens.

Pink Car hit the roadblock at 80 miles an hour—and the two cars across the road barely moved. But the stunt was highly successful, and the stunt driver managed a sliding, 180-degree turn after crashing through the roadblock. It was more than a director dared hope for.

From that stunt, the best picture was the one taken from the roof with the telephoto lens.

For the next stunt, Pink Car would crash through a series of stacked boxes. I was allowed to stand next to the movie cameraman for this sequence, a position so close to the action that I used a 35 mm lens. The noise was so great, the sound man stood next to me and assured me the movie-drive camera would be no problem.

The final stunt I filmed was the most complex. Pink Car would crash through the front of a building, bringing down the roof and splashing through fruit set up in front of the building. A stunt man would be on the roof and would leap off at the last second.

I selected a shooting position across the street in a second-story window. The building was condemned and boarded up, and I had to pry open a door to enter.

Empty boxes and baskets fly as Pink Car goes out of control in a parking lot. The noise of this crash was so great that the photographer was allowed to stand next to the sound recorder. Data: Nikon F with motor drive, 55 mm Micro Nikkor lens, 1/1000 sec. at f/8 on Tri-X film.

At one point, my foot broke through the rotten floor.

But the vantage point was excellent. The motor-drive Nikon had an 80-200 Nikkor zoom lens that would allow me to follow any possible action and frame the picture exactly. I again shot at four frames per second.

From these three scenes I've just described came some pictures the producer liked so much he ordered 500 of each and sent them out in his press kits.

While the movie company was in town, I learned a lot about how a well-equipped movie photographer travels. The movie crew had a van full of equipment that could create any desired mount for a camera in an hour or less.

One such mount went on a tree for one stunt. Another mount was made for inside the car. Another was made to mount a camera beside a wheel on the car.

One interesting idea called for shooting into a mirror that would be smashed by Pink Car. The camera was mounted on the ground just beside the path the right wheels of Pink Car would travel. The mirror was in the area Pink Car would pass over. An Eyemo 35 mm movie camera was aimed into the mirror, giving the final impression that the car was traveling directly at the camera until impact.

The experience of working near a movie company is invigorating. Don't miss out if one comes near your area. I even got an offer to become a contract screenwriter-photographer—almost too good to turn down. Sometimes, when depression sets in, I wonder about that decision.

23

Making a Strobe Slave

If someone asks what avocation can most help the aspiring photographer, chances are good the first answer will be art, or maybe writing.

While both are helpful, in my opinion another correct answer would be electronics. Most photographers sadly know little about electronics and feel as lost in the language of electronics as laymen do in the language of photography.

That shouldn't be, so I'll introduce you to the most basic electronics work. I'll teach you specifically how to construct a slave unit for an extra strobe that will cost you about $1.72 in parts and about five minutes of time (much less than even the cost of stringing cord between strobes, and far more convenient, of course). Then I'll examine the multitude of electronic devices you can make at home to trigger your camera in a variety of remote situations.

First let me say that vast knowledge is not needed to construct simple electronic kits. Everything I will propose can be purchased in kit form, complete with easy-to-understand instructions and directions for use. That is the only route to take as a beginner in electronics. Later on you can design your own devices. (When you do, you will find that photographic developing of copper plates is now standard procedure in creating exotic printed circuits.)

Building your own electronic devices has two real advantages: You will save a bundle of money; and you will enjoy a sense of satisfaction in having

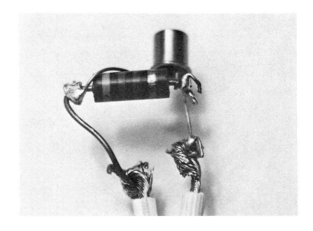

To make a light slave, first twist the wires into semi-solid joints as illustrated in the diagram.

Then solder the joints together.

done it yourself. (Your device will probably be more reliable than a lot of imported junk, too.)

The language of electronics is Greek to most people. I'll reassure you that you don't need to know a transformer from a resistor to follow the directions in a kit. The kit will tell you what goes where.

But I'll also assure you that after one or two kits, you will indeed know that resistors have little bands of color around them and restrict the flow of electrical current, that capacitors store electricity, that transistors have replaced vacuum tubes and amplify a signal they receive, or that diodes rectify current or detect a signal.

Don't be scared, now. I promised you wouldn't have to memorize that stuff. It will come naturally.

To work with electronic kits, you will need a minimum of tools. A soldering iron tops the list. These are cheap little devices and the most simple will handle your needs and costs under $4. A good wire stripper for under $3 will serve you forever and will be a blessing. Solder is cheap. (Be sure you buy only rosin core solder.) You should already have needle nose pliers, screwdrivers, and a tool box. You are now ready to buy a kit or its components.

If you can follow instructions that read "attach A to B," then you can build a electronic device. Anyone who has successfully put together a child's tricycle the night before Christmas will find kit-building a breeze. The only skill you need to acquire is correct soldering technique. And even if your soldered joints look like chunks of moon rocks,

The completed assembly is epoxied into a thimble-sized light slave. A ball of clay is being used here to hold the epoxy until it dries.

The wire is cut off and a household plug tip is snapped into place. The completed light slave works well in all but bright sunlight conditions.

chances are good your device will still perform.

So let's plunge in with the slave unit. This is not a kit because it's too simple. It only uses four parts: a household plug tip, a short length of cord, a 47K, ½-watt resistor, and a light-activated, silicon-controlled rectifier (LASCR).

That last item is a choker to ask for, but it's really a super sophisticated transistor sister. It's a switch that turns itself on in the presence of the right amount of light.

Any electronics store should stock the resistor and the LASCR. The resistors come two to a package and cost 25 cents. The LASCR at Radio Shack (part number 276–1095) costs about $1.59.

You have to make only four solder joints for this little project. The LASCR has three legs sticking out beneath it. Technically, these are the cathode, the gate, and the anode. Think of this tiny device as the switch it is. Current comes up the anode leg to the gate. The gate blocks the flow unless the correct amount of light is present. That amount will be determined by the amount of resistance you apply to the gate through the resistor.

If the amount overcomes the resistance (sort of like a wrestling match) then the resistor gives up and lets the current flow on through the LASCR and out the cathode.

That's the same thing as throwing a switch, when you switch the lights on in your bedroom. Only this switch is controlled by the blip of a strobe.

Next plug in your soldering iron, remembering not to leave it lying on the

135

bedspread unless your home insurance is paid up. Let it heat for maybe five minutes. (Don't touch it to test it.) Put the resistor between the gate and the cathode legs of the LASCR. Wrap the legs around the resistor wires tightly. It is on these wraps that you will apply solder.

In applying solder, the idea is to heat the joint for about three seconds, touch the wire-like solder to the joint for two seconds, and then remove both iron and solder core. It doesn't always work out that way, but that's the way you're supposed to do it.

So, with one hand hold the resistor wire *opposite* the side to which you will apply the soldering iron. Hold the LASCR with the other hand. With a third hand apply the soldering iron, and with a fourth hand apply the solder. You can see right away that the job isn't as easy as first anticipated. Use a table, your knees, or your wife in place of hands number three and four.

Let the solder flow over the wrapped joint and then let it cool for about ten seconds. Tug lightly to make sure the joint is secure. Now do the same thing at the other connection of the resistor.

Be sure through all this that you don't heat up the LASCR legs. Transistors don't like heat any better than your fingers do. If you have a heat sink (for dissipating heat), attach it to the LASCR leg nearest the joint being soldered. If you don't have one, use a fifth hand to hold the needle nose pliers on the leg.

You have two more joints to solder. The cord from the household plug to the LASCR is soldered one side to the anode leg, the other side to the resistor-cathode connection.

That's it. How simple can it be?

Plug the household plug into your strobe, fire another strobe aimed at the LASCR tip, and both strobes should go off simultaneously. If not, you may have a bad LASCR. That's rare, but it did happen to me while I was constructing a remote triggering device to be used at a Cape Kennedy space launch.

Now you have a simple system for using multiple strobes for better lighting. Many photographers consider three strobes ideal. For that setup, you need one strobe on the camera to trigger the other two. The other two are controlled by the slaves you made—at a total cost of under $3.50.

24

Electronic Kits

I'm not sure how many places offer electronic kits, but most of mine were purchased at a local Radio Shack store. Their perforated-board kits are extremely simple to construct, featuring detailed instructions on about a sixth-grade level.

Other companies offer kits also, but these are most often found in local, non-chain stores, and I can't direct you to those in your town. Search them out on your own. Motorola offers detailed instruction sheets on a variety of kits using their HEP components. Other instructions may be found in any of several electronics magazines.

The most basic kit to tackle first is the voice-operated relay kit, Radio Shack number 28–131. The kit costs about $6.95 and will serve as a sound-activated trigger for your motor-driven camera, and double as a relay switch for several other control methods.

Its basic design is for use in controlling tape recorders. When you speak, the recorder turns on. When sound ceases, the relay waits about two seconds, then shuts off the recorder.

It is used illegally to trigger eavesdropping bugs. Since bugs are battery-operated, their useful life can be greatly extended by having them operate only when sound is present in a room.

By the way, the deeper you become involved in electronics the more you will come to realize how incredibly easy it is to build a bug for under $5, to build a jammer that will throw your

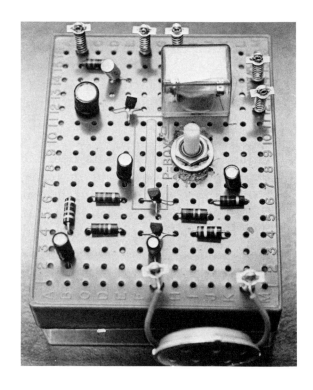

This perforated-board sound slave kit from a radio store is relatively easy to make and is used in connection with other kits as a relay system. The microphone is at the bottom in this picture and the relay is contained in the plastic cube near the top.

neighbor's television picture into a sea of snow, to build speech scramblers and unscramblers. I in no way encourage the use of illegal equipment, but you will soon realize how control of that use borders on the impossible.

Back to the sound slave. If you've ever wondered how those remarkable pictures of bullets leaving the barrels of guns were made, of balloons bursting at a pin prick, of light bulbs shattering under a hammer blow—well, they all began with a sound trigger.

The kits come in plastic boxes perforated with holes for locating the resistors, transistors, capacitors, and relays used. The instruction sheets with each kit are sufficiently detailed so you won't mistake a transistor for a resistor. Have no fear.

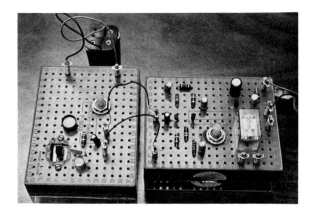

A light switch on the left is joined to a sound slave which is then wired through a household plug to a motorized camera. The sound slave (minus the microphone) is essential because it alone contains the relay needed to trigger a camera. A shadow can be made to trigger either a camera or strobe with this setup.

A second useful kit is the light-operated alarm kit, Radio Shack number 28–128. It costs about $4.95. This device triggers an alarm when a beam of light is interrupted.

The source of the light can be the sun or a flashlight. An adjustable potentiometer on the alarm allows you to set the available light level, so that only a shadow will trigger the device.

You can use this in any number of

applications. A set of remarkable photographs of insects in flight appeared in the November, 1975 issue of *Popular Photography*. In each instance, a light trigger device was used (much more sophisticated than the Radio Shack kit, of course).

These devices can be used at the finish line of races to catch the exact moment of contact with the ribbon, for instance. I have used the device beneath a hurdle to catch an exact posture of a hurdler through a fisheye lens also beneath the hurdle.

The light device, then, can be used in any situation where a shadow can be created or is present. Industrial applications include counting products coming off assembly lines and use in burglar-alarm systems (sometimes with the use of infrared light).

To use a light trigger with your motor-drive camera will require connection to a relay between the light device and the camera. Here's where your sound slave comes in handy. Simply remove the microphone from the sound slave and remove the buzzer from the light device. Now connect these terminals with straight pieces of wire. The end product is two devices connected in tandem, with the sound slave actually triggering the camera.

Another useful kit is the photo night-light kit, Radio Shack number 28–126. It costs about $2.95. This device turns on when a room darkens. It can be reversed to turn on when a scene

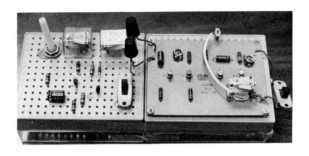

This is a custom-made timer, or intervalometer, that costs under $10. A timer purchased from a camera shop will sell for $300 to $800. This one is fully adjustable from instantaneous to four minutes. The timer part is on the left; a sound slave is on the right (a different kit from the others shown). Motorola produces schematic drawings for the timer constructed here.

brightens. This might come in handy should you want to leave your camera in a location for pictures of dawn breaking. You wouldn't have to get up that early (an important consideration to those of us who wander around at all hours of the night).

One of the most expensive devices available to photographers carries the fancy name of "intervalometer," a big word meaning a timer. Designs for simple timers are available in the Motorola pamphlets I mentioned earlier, and I constructed one that triggers the camera at preset intervals between two seconds and five minutes.

Ralph Morse of the old *LIFE* magazine staff once used an intervalometer in a submarine bell to record snatches of life at preset intervals. The timer was the only way he could capture candid activities aboard the bell.

The timers can be used in tandem with other devices to prevent the cam-

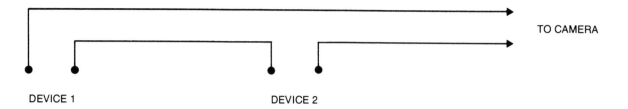

TO CAMERA

DEVICE 1

DEVICE 2

Instructions for wiring two devices in tandem.

era running through a roll of film too quickly, or to prevent it from taking only one picture.

Here's how to wire two devices in tandem so that both must be triggered to actually fire the camera: Radio Shack has come out with new "project boards" that I haven't tried yet, but they promise simplicity of construction. One of them, number 277–113, is for an electronic timer and costs about $2.99. It operates from zero to six minutes. You'll have to buy parts listed on the instruction sheet.

One discontinued kit I use is a water detector that sold for about $2 and closes a relay when rain or water strikes a copper indicator.

And one kit I haven't finished modifying yet is called a "goofy light." It fires five small bulbs in sequence or at random (your choice when you wire it up). The five bulbs fire in less than one second, so used with my strobe-slave devices, I might be able to create a rapid strobe sequence with perfect spacing.

A strobe sequencer that you can operate at any speed can be made with the aid of a rotary switch. Buy a switch with 10 or 12 contact points (about $2). Then connect cords with household plugs, or strobe cords, to the switch contact points. To fire the strobes, you plug in a cord to each, then twist the dial from point to point, each point firing one strobe. I've used this numerous times, on roller skaters, pole vaulters, yo-yo champions, and bicycle racers.

You'll find the electronics store is stocked full of switches begging for a use in your camera work. I've used a mercury switch to trigger the camera when a roller coaster turned downward at the top of the ride. I've used a micro-switch attached to a tennis racket to capture the squashed tennis ball on impact.

Let your imagination run free. Electronics technology is within easy reach of any photographer who takes a little time to learn the basics.

25

The Streak Camera

How many times have you found a special photograph, admired it, and sought to find out how it was done?

This happened the first time I laid eyes on the streak camera pictures of George Silk. They produced an unbelievable effect of speed with their blurred backgrounds and clearly defined main subjects.

Neil Leifer used the same technique to picture Olympic skier Billy Kidd. I was impressed and began the search for how it was done.

Well, it wasn't much help to find it was done with a modified Nikon camera, especially prepared for the photographers by the engineering staff at *Life* magazine.

Then I found that a New York camera repair shop supposedly modified Nikon motor-drive cameras to take such streak pictures. I dashed off a letter seeking a cost, but never received a reply.

I decided to search for my own answer. The camera would function like those in use at horse racetracks. Such cameras are also used sometimes for aerial-strip pictures (continuous pictures of the ground).

To produce the image, the film, not the shutter, moves. And the film must move at the same proportionate speed as the subject. This sounded very complex, but I started to experiment anyhow.

I had an old Nikkorex F camera—my first camera purchase—that

had seen better days. Its shutter was somewhat unreliable and I didn't have the money or the inclination to have it repaired.

Still, I was hesitant to wreck its shutter. I had read that Larry Mulvehill had managed to first wreck his motor Nikon shutter before discovering he could produce streak pictures without destroying a good camera. There had to be a way.

I considered what I needed. To move the film across a slit that serves as a kind of shutter control, I needed a transport motor. To make a long story short, I tried many motors before I found one with sufficient torque to pull the film evenly through the camera. The motor was from an ice-cream maker.

Next I had to tie the motor to the camera somehow. A sewing-machine dealer produced a belt and several size sprockets. A small sprocket was glued to the rewind knob of the Nikkorex. The large sprocket was attached to the ice-cream motor. The belt tied the two together.

The Nikkorex rewind mechanism is triggered by a small button beneath the camera. So I mounted the camera on a board with a small nail protruding an eighth of an inch from the board in the area of the rewind button. This held the button up and allowed continuous rewinding.

A ¼—20 screw was placed through the board and screwed into the cam-

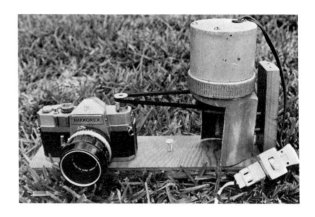

A makeshift strip camera (or streak camera) uses an ice-cream motor coupled to the camera's rewind knob with a belt. The switch purchased at a hardware store allows the motor to be turned on and off at the camera position.

era's tripod socket to lock the Nikkorex in place.

Before pictures can be taken, a roll of film is first "shot" and wound from cassette to take-up sprocket. Needless to say, the "shooting" of these pictures is done with lens cap firmly in place.

Now you have a camera with film on the take-up sprocket ready to be rewound into the cassette. The film will be pulled past a small slit made in black paper. (I cut a piece from the envelope that comes with printing paper.) The size of the slip is about 1/2000th of an inch. But forget the measurement—just take a razor blade and slice from top to bottom in the middle of the shutter area, making sure not to cut your shutter curtain. Open the shutter and hold it open on time exposure before using the razor blade.

This closeup view shows the belt secured around a sprocket attached to the rewind knob. The sprocket was attached with fast-drying glue.

The interior of the camera is altered with a strip of black paper into which a small slit has been made. In this view, the film winds from the right takeup reel back into the cassette on the left.

Pictures are made by first locking the shutter open on "Time" and then triggering the ice-cream motor. The subject must move in a direction opposite the direction of film travel.

Using a streak camera is largely a matter of trial and error. First make a series of photographs at bracketed *f*-stops to find your equivalent "shutter speed." If *f*/32 is your bright sunlight exposure on Tri-X film, then your "shutter speed" is 1/125 sec. Your *f*-stop will vary with light conditions, but will always be found opposite 1/125 sec.

Remember, this is the *f*-stop shutter speed I found by trial and error for my particular streak camera. The combination you must use depends on the size sprockets you use on both the motor and the camera-rewind knob. For a slow motor, and an ice-cream motor is very slow, the effective speed can be increased by increasing the size of the sprocket on the motor.

By trial and error, you can vary subject speeds through a series of interchangeable sprockets on the motor. I have two sprockets at this time, one the same size as the one on the camera-rewind knob (effective for subjects moving about 5 miles per hour) and one 8 times as large as the rewind sprocket (for subjects moving about 25 miles per hour).

To find your effective subject speed, aim the camera at passing traffic in various speed zones. When the tires of passing cars are rendered perfectly round on your negative, then you have found your correct subject speed.

Incorrect speeds will either compress or expand the subject, depending

144

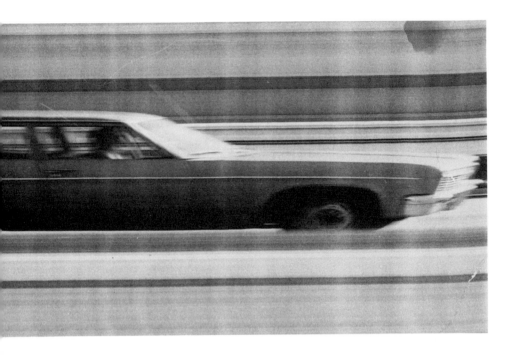

A miss with both cars (top). The car on the right is traveling too slow for the strip camera. The car on the left is accelerating, but note that the front wheel indicates a speed too slow while the rear wheel is traveling too fast. Only the front car door is properly rendered. The photo below is an example of perfect timing between the camera's film speed and the subject. The car is rendered in perfect proportion while the stationary background is blurred.

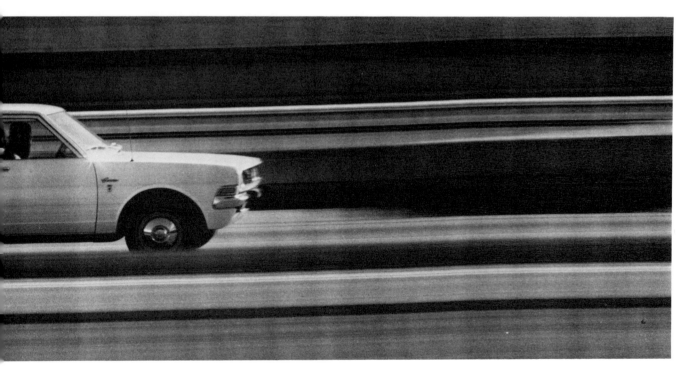

on whether the subject is moving too fast or too slow for your camera. The tires will appear egg-shaped.

People walking are interesting to photograph at the slow speed possible with small sprockets. But since feet move faster on the forward and backward swing than the remainder of the body, the feet will stretch out or compress, depending on their direction of movement. You may find this an interesting distortion. Personally, I dislike it and wouldn't use it very often.

If there's one problem with the camera, it's having to be tied to an electrical outlet. So far I've been able to plug in and trail cord behind me, but the situation will arise someday where I need a battery-powered motor.

With this camera, the picture appears as a frozen subject against a streaked background. Anything stationary is blurred; anything moving at film speed is frozen.

The total cost is $1 for the belt and sprockets—and it works beautifully.

26

Launching a Rocket Camera

Photographers are really just little boys or girls in the bodies of adults. They think life is one series of adventures after another, they crave excitement, and they relish gadgets (toys).

The little boy in me made me buy that rocket camera. I paid $3.95 for it, put it together following instructions, fired it to 1000 feet atop a model rocket, retrieved it from a wet field, and developed one of the fuzziest pictures I've ever made.

But it *was* a picture—a picture that was made from quite a unique position and all that one could expect from a $3.95 camera. All in all, the little circular picture is quite remarkable.

The camera used is called a Camroc and is made by Estes Industries, probably the biggest name in model rocketry. Model rocketry has "soared" in popularity and now ranks fourth in sales totals at hobby shops. As the sport grew in popularity, more accessories became available. Estes was first with the Camroc and the Cineroc (a movie camera).

I bought the Camroc on sale as it gathered dust on a dealer's shelf. Today it lists for about $8.95. I put it together along with its carrier rocket (about $2.95) and waited for an appropriate occasion to blast the contraption into space.

The first annual model rocket meet announced for our town provided me with an occasion. Sponsored by the Boy's Club, the event attracted several

hundred young boys and a few grown ones, me included. But I was the only one with a Camroc (and Cineroc).

The Camroc is simplicity itself. It's about four inches long, weighs only an ounce or so, and is made of plastic. Its shutter is triggered by releasing a rubber band (about 1/1600 sec. equivalent speed). It has a hole that serves as a fixed diaphragm (about f/16). It has one lens element and takes one picture per launch on special 1½-inch circular film.

The film must be loaded in total darkness, so a darkroom or changing bag is needed. I take the changing bag into the field wherever I go, and have used it at rocket launches. For the Boy's Club event, however, I preloaded two film holders.

The camera has three segments, taped together for flight: the top, which has a small plastic porthole, the shutter, and the Waterhouse (hole) diaphragm; the middle, where the film holder is located; and a bottom to connect the camera to the model rocket.

Once the camera is loaded, a string tied to the shutter is pulled taut and tucked through a slot in the bottom of the camera. The camera then fits tightly in the rocket tube, which holds the string tight (thus holding the shutter cocked for later release).

Here's the tiny rocket camera that was launched to 1000 feet. The black object at the top, with three bands of tape around it, is the camera. The lens porthole is in the nose of the rocket. The picture is taken after the rocket pitches over at its apogee. Ignition wires are being connected here to the bottom of the rocket prior to firing.

A metal slide similar to those employed with 4 × 5 or larger cameras protects the film from exposure through all these steps and is removed only after the shutter is cocked and the camera is on the rocket ready for launch.

The rocket is ignited from an automobile battery connected through a

148

This is the picture taken by the rocket camera. A baseball diamond is visible
near the bottom; residential houses are seen in the upper half of the picture.
The white around the edges of the picture is the result of light leaks.

switch to the rocket's solid propellant engine. The engine, shaped like a shotgun shell, blasts for less than one second of burn time, accelerating the rocket from 0 to 300 miles per hour, from ground level to 1000 feet. The camera will undergo 7 Gs (seven times the gravitational force) of stress and winds of 300 miles per hour.

After the power burn, the engine trails smoke for tracing purposes for about seven seconds, then fires a final charge that ejects the Camroc and its parachute. When the camera is ejected, the string is released from the rocket body tube—firing the rubber band shutter. It's crude, but it works.

After the parachute brings the rocket back to earth, reinsert the metal slide and then remove the film holder. You can fire another and another if you like.

Estes develops the film, but I thought the charge excessive and the time delay atrocious (three months or more), so I developed my own in D-76 at 75 degrees for eight minutes. I held the film by an edge with a pair of tweezers and used open tanks of developer and fixer.

The image was rotten by the standards I've come to accept. But let me tell you it was a smash hit with the Boy's Club members (who don't possess my photo standards).

The camera had been caught up by winds at high altitude and had pitched over incompletely, firing at a tilt instead of straight down. But it had caught a view of the baseball diamond behind the Boy's Club and that gave a recognizable reference point to the picture.

I contact printed the negative and sent that up for engraving. The fuzzy image won't stand much enlargement, if any.

It was worth $3.95 just to produce that one picture that gave such a kick to the local Boy's Club members. And for me, it was as much a thrill as I've had since I worked on a Boy Scout badge and got back a good roll from my Brownie Hawkeye.

27

Art from Photography

Art and photography have merged so much in recent years that few people can say where one ends and the other begins.

Is art somehow diminished when the artist first snaps a picture of a subject, and works from that picture? A famous editorial cartoonist snaps a Polaroid picture of a pose, and then uses that picture to show him where to draw folds in clothing and to assure accurate posturing.

Is it not art if the artist uses a photographic slide projected onto his paper, and paints or draws from that slide image? Many newspaper artists do this.

Is it art or photography when a picture is inked over and the photographic image is then bleached off?

I won't pretend to have the definitive answer to any of these questions. Photographers and artists have heated debates in seeking answers. And the answers may have to await judgment by historians.

My own opinion is "who cares?" If you like it, use it.

If you don't have an artist on your paper's staff, then artistic use of photography is a proper substitute. I'll tell you how to "cheat," how to produce what at least looks like "art" and may even ultimately be judged "art." Nobody will know or care, and besides, it's fun to do.

If you have a darkroom, then you can easily do the following steps. First,

A straight print of an ascending hot-air balloon can be transformed into a piece of artwork.

select a simple picture, preferably with large areas of black and white. Avoid complex subjects like landscapes or portraits at first.

To demonstrate the technique, I chose a photograph of a hot-air balloon. The picture contained bold blacks and whites, plus only a few lines that would

require careful and steady hands.

From a negative, make a high-contrast print. I used F4 paper, which is very contrasty. This step drops out most "grays" within a picture, grays you will not need.

Dry the print without gloss.

Now you will "ink" in the picture.

An artists's pen, india ink, and photographic bleach were used to produce this picture. The balloon outline was traced with ink and then the photo image was bleached, leaving only the outline.

Use waterproof black India ink and a fine artist's pen. Take your time. Be careful. Work from top to bottom, to prevent smearing any wet ink as you continue to work. After you've done this a few times, you may feel the urge to alter the picture. Go right ahead. You're the "artist."

When the inking is complete, the next step is to bleach off the photographic image. To do this you prepare a tray of photographic bleach by dissolving 3 or 4 teaspoonsful of potassium ferricyanide in 32 ounces of water. (You can buy ferricyanide at any photo supply store.) This is potent stuff, so don't

splash it about if you value your clothes.

When all the ink has dried, you place the print in plain water first, to wet the paper. Then put it into a tray of fixer for two minutes. Next it goes into the tray of bleach for whatever time it takes to dissolve all the image except the ink. It should take only a minute or so.

The print will turn an awful yellow color. Don't be alarmed. Most of the yellow will wash out. By the way, the fixing and bleaching can be done in room light. This part of the job doesn't require a darkroom.

When the photo image is gone, place the inked print into a tray of washing water for about an hour. After that, the final step is to dry the print in normal fashion. You now have what appears to be a hand-drawn pen-and-ink sketch. Is it art? Who cares?

I've done the same thing for other subjects, including a parachutist, a few portraits, and one landscape (too many lines to draw). You'll soon learn to make your contrasty print very light, just light enough so you can see to ink in the lines. A light print will bleach easier and more thoroughly.

Don't worry if the print has a cream color imparted to it from the ferricyanide. You're printing for a newspaper in black and white and the slight yellowing won't show.

To make the print look as much like a pen and ink drawing as possible, employ cross-hatching techniques for shadow areas (beneath the balloon gondola, for instance).

I'm aware that high-contrast prints made without an inking process are possible, but those *look* like photographs. The inking process helps to get away from a photographic appearance.

If your paper is a small one and you have to play artist as well as editor, reporter, and janitor, then you might consider copying from a slide projection.

Set up a slide projector, perhaps with a mug shot of a star athlete in the tray, and throw the image onto a sheet of artist's paper. Ink in the outline of the portrait and then fill in the details. At some point, you'll want to remove the slide projector to free the picture of the stark shadows it creates.

Finish the picture as you see fit. The artist's ability is an acquired one. The more you practice, the more skilled you will become at creating acceptable ink drawings.

28

Panon Distortions

Welcome to the world of a very strange camera called the Panon. The model I use is presently out of production, but it's modern equivalent, the Widelux, is still produced and available at about $500.

The camera is basically an extreme wide-angle model that takes in a horizontal field of view of 140 degrees. It produces a 2¼″ × 5″ negative, whereas the Widelux negative is about 1″ × 2¼″.

The measurements aren't exact because exactness is not important. What is important is that you will need a 4 × 5 enlarger to blow up the Panon negative, and a 2¼ enlarger for the Widelux.

In explaining how the Panon works, let's first consider the normal action of a focal-plane shutter. When the shutter trigger is released, two curtains containing a small slit pass across the film, from one side to another.

But in the Panon, the front lens swings in an arc and the slit again passes from side to side, but in a curved fashion. The 120-type film is rolled into a curve to receive the exposure from the swinging lens.

Now let's consider one of the more unusual applications made of the Panon. It should be obvious that the camera is ideal for wide-angle views, although it does produce something called cylindrical distortion. What is not so obvious is the unusual tricks that can be performed using the swinging lens.

An out-of-production Panon camera is used for the trick photographs in this chapter. The Panon features a swinging lens that exposes film as it sweeps from left to right. It has shutter speeds to 1/250 sec. and *f*-stops to 22.

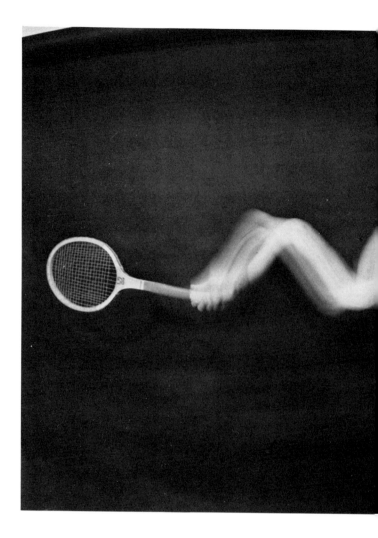

My complex picture idea began when I learned that tennis hustler Bobby Riggs was coming to town for a vacation and some tennis. I mentally pictured an image of Bobby with a grotesquely long arm reaching out to strike any opponent's shot.

The Panon could carry this off on the negative, but the idea would involve a complex procedure. The photographer would first let the lens swing the distance of the tennis racket, would then move the camera as the lens exposed the arm, and finally would let the lens again swing freely to expose the full figure of Riggs.

I wanted the racket to be perfect imagery, the arm to be elongated, and the figure to be perfectly rendered, but it didn't work out that way. It could have if we had done it right, it's just that there is many a stumbling block from idea to execution.

I first obtained permission from Riggs, a truly likeable fellow, who agreed immediately and wanted some prints. I knew we would need a black background, since the background

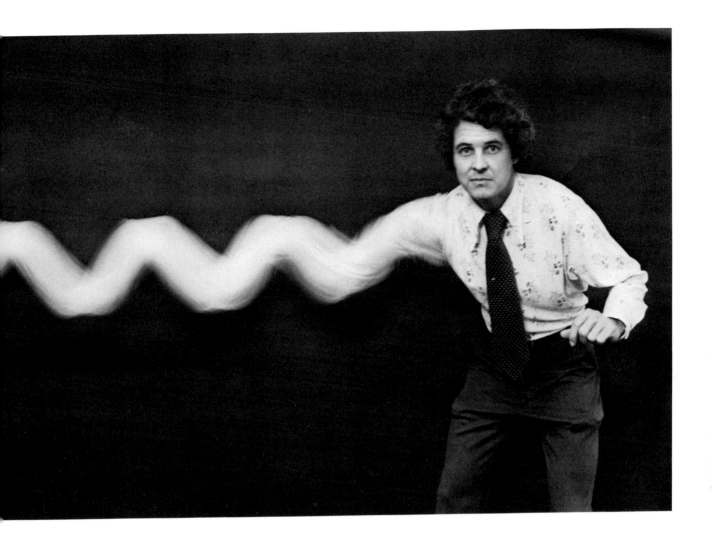

would blur as we moved the camera. Black backgrounds show no details, and thus no blur would be evident. So I elected to shoot the picture at night, outside.

Although the night turned out incredibly cold for Florida, Riggs was dressed in tennis shorts at our instruction. It was difficult for him to hold still as the picture was being exposed. De-

Because a one-half second exposure takes several seconds to complete, the Panon was placed on a tripod. For the first part of the exposure (the left side of this print), the lens was allowed to swing while the camera remained stationary. When the lens' view reached the arm, the camera was moved so that the lens appeared to remain in one place. The model then waved his arm up and down to create the wavy lines shown here. To expose the model's body, the camera movement was stopped and the lens was allowed to complete its swing through the stationary model. Data: Panon, 26 mm lens, 1/2 sec. at f/22 on Tri-X film under floodlights.

spite some liquid "antifreeze" fortification, Riggs was so cold the photographer could only click three pictures before Riggs began to turn blue and finally fled for the warmth of his apartment.

We went to develop the pictures. (The *Manatee Times'* photographer had taken the pictures while I directed Riggs.) One was off-center. One was a mess in which we caught too much of Riggs' full figure and ended up with multiple Bobby Riggs. The other was close, so very close. But the tennis racket was blurred, and Riggs hadn't been able to stand completely still in the cold. Thus, his face blurred slightly.

It was back to the drawing board—literally. I draw out picture ideas for photographers and had sketched exactly what I wanted. It was to be a photo-caricature. Riggs would be frozen on the right side of the print, with a plastic-like arm extending in waves across the print to a frozen tennis racket on the left.

The exposure we were using is called a half-second, but that means a half-second for each section of the film. The rotating lens takes ten seconds to swing its arc. So Riggs, in effect, had to remain still for ten seconds (except his moving arm, which I ordered into action on cue).

The next day we were out to see Riggs again, this time carrying a proof sheet of our failures so he could see the exact effect we wanted. Several minor alterations were made in pose and action.

We couldn't wait for another night so we brought a black paper backdrop and two stands with us and set up at a local tennis club where Riggs was playing. The exposure reading for a half-second in the shade was *f*/22 on Tri-X.

This time we managed four pictures before the posing became nearly intolerable. Each picture was so difficult it required about five minutes to execute, with constant spoken directions needed during each exposure.

Back to the darkroom. Again, four pictures came only close to what we wanted. Somehow, this time we had missed the arm and had blurred the tennis racket. That definitely wasn't what I had in mind. But by now, time had run out. The picture was due for engraving to run with a news story. I chose the best one of the four.

As it turned out, the print did not contain sufficient contrast. The end result in our paper probably didn't seem that bad to the reader, but to me it was a failure. The racket was lost and the effect wasn't as planned.

I was too embarrassed at the results to go back and apologize to Bobby Riggs in person. I did it through a photo column in my paper. At the time, I wrote, "You should know, Bobby, that we really appreciated your cooperation, that we're not country bumpkins, and that we're hard at work modifying the camera so we can assure exact results if

the effect is needed again. Next time . . . you see, Bobby . . . we have this great idea sketched here on paper . . . and all you have to do is . . ."

I understand Riggs loved it.

That was the end of my episode with the delightful Bobby Riggs, but I was irked at the failure and determined to obtain the effect.

Actually, all I did to the camera was add a bent paper clip to be used as a gun sight. And then I trained the camera on fellow photographer, Dick Dickinson.

Bingo, it worked. First time.

I put the camera on a tripod and set up the flood lighting. Then Dickinson extended his arm and I triggered the camera. Following the action of the camera slit by sighting over the paper clip sticking up above the lens, I let the camera lens rotate freely across the tennis racket. Then I called for Dick to move his arm slightly up and down, and I moved the camera by rotating the tripod head while the gun sight remained fixed on his arm. Finally, I let the camera again remain still on the tripod while the lens finished its arc.

This picture is done in a vertical format, but uses the same technique as the horizontal shot. The model leans over, with arms near the floor. The lens swings upward, exposing feet and hands and then the model slowly straightens up. The camera is moved so the lens sees the same part of the model throughout the middle part of the exposure. Finally, the lens is allowed to complete its arc on the head of the model. Data: Panon, 26 mm lens, 1/2 sec. at f/22 on Tri-X film under floodlights. Photo by Dick Dickinson.

The picture was used on page one, with an explanation of the Riggs failure.

Dickinson became excited over the camera and trained it on me. But he chose a vertical mode of operation. I stooped over with my arms near the floor, the camera began to swing from bottom to top, exposing my arms, and then I slowly straightened up.

The result is a comic picture. The posture would be perfect if we were picturing a dock worker holding a heavy box. I might do that sometime.

The technique for these pictures is not new. As far as I know, the first commercial use was by sports' greatest photographer, John Zimmerman. He has used the technique many times, with the best result a photo of the twisting torso of a shot putter. The final picture illustrated a corkscrew person heaving the shot.

Remember that to create distortion, you can either move the subject or the camera. The camera is always moved in a direction opposite the lens' direction of travel, thus exposing the same area continuously until you stop moving the camera. A moving subject, for instance a turning one, offers a different part of the torso to each section of the film as the slit travels slowly.

It makes for fascinating experimentation.

29

A Fresnel Lens Helps

The best pictures newspaper photographers produce are most often the result of challenging assignments. Routine assignments invariably produce routine pictures. But putting a challenge in each assignment is asking too much of the daily newspaper editor. (I won't defend the weekly editor, however, who should be thinking ahead and has no excuse for mediocre pictures.)

The editor, then, must devise some assignments that go beyond the daily fare. So I devised a 27-part series on minor sports, called "Sports Specials." I included such sports as ballooning, glider flying, skin diving, swamp buggy racing, various track events, and the like. The one I'll examine here is water polo.

Water polo is not a major sport in the United States. In fact, it is rarely played. In our area, it is used by a high-school swimming coach as playful exercise for his swimmers. Basically, it builds endurance and stimulates competition.

The assignment of a sports special photograph was done weeks ahead of the scheduled running date. There is no excuse for deadline pressure on feature photographs; I always want to give the photographer sufficient time to think through his part of the task.

As editor, I had envisioned the picture I wanted after researching as many pictures as I could find of the sport. Most of those pictures were disappointing. They were either above-

water views of action or below-water views that showed kicking legs and various illegal grabs.

I wanted both above- and below-water views in one picture. With the photographer, I talked over approaches to the picture. We rejected using two cameras at once because the water line would have to be faked, and we knew we couldn't afford a ground-glass device designed especially for split-level views.

Using an underwater camera, such as the Nikonos, was out, because we couldn't see what we would be getting. Besides, it seemed no matter what we did, we'd have to settle for a strange looking picture distorted by what's called refraction.

Refraction means that things underwater appear larger, or magnified in relation to the same object out of water. Our pictures would have tiny heads perched atop huge bodies. And that wouldn't do.

We needed to "reduce" the bottom half of our picture. We could find no cheap filters to attach to the lens to accomplish this reduction, although Floridian freelancer Ozzie Sweet has such a device. We had no desire to have an optician work on valuable lenses. Then I remembered an inexpensive item called a Fresnel lens, which can be attached to glass to provide "fisheye" or wide-angle views. The Fresnel lens is plastic and simply sticks on glass.

For our picture, I figured we had

An aquarium and a Fresnel lens proved to be all the equipment needed to capture a view of water polo as seen from both above and below the water at the same time. The Nikon F camera with a wide-angle lens was placed in the aquarium, and the prism was removed to allow framing of the picture directly on the ground glass.

no need for any special underwater housing, an aquarium would do fine. I borrowed one from a neighbor.

The Fresnel lens was cut in half with a pair of scissors and the bottom half was positioned on the inside face of the aquarium, with the top line roughly where we wanted the water line.

At the swimming pool where the team practiced, we talked with the

Here's the resulting image of water polo. The water line is not perfect, but long time intervals were needed between shots to allow the wave action to subside in the pool. Perfection would have taken too long. Data: Nikon F, 20 mm lens, 1/500 sec. at $f/11$ on Tri-X film.

coach about what we had in mind, and then talked to the swimmers. It would be necessary to keep the water quite still—no waves—and that meant our action would have to be staged.

We went through rehearsal and it looked very good.

A Nikon motor drive with its prism removed (so we could look down directly onto the ground glass) and with a wide-angle lens was lowered into the aquarium. Then I pushed the aquarium down into the water while photographer Dick Dickinson viewed on the ground glass.

The rolling pool water made it difficult to align the top of the cut Fresnel with the water line, so we snapped numerous pictures. The camera saw a scene divided in the middle by the water line.

I directed the coach, who in turn directed the team players into position and action. They didn't mind repeating the same thing over and over. It was good exercise. After each bit of action, however, we had to wait about five minutes for the pool waves to settle down.

There is a slight exposure difference between surface and sub-surface, but this was easily compensated in the darkroom. We used the surface exposure reading.

In the selected picture, the bottom half (the underwater part) is slightly diffused. We still aren't sure whether this was the effect of the Fresnel lens, or the water, or both. But it actually seemed to add to the realism.

And now for the "bottom line" of the story: The picture so impressed our senior editors they ran it eight columns by half a page.

30

Inside a Car Trunk

I'm going to satisfy your curiosity and describe to you what's inside the trunk of my car. Every photographer is curious about what equipment his competitor finds essential. We'll call this "tools and accessories I know and love," with a subsection on "photographic junk."

Let's first examine the camera equipment. I use a Nikon F with a motor drive as my basic camera. My lenses fluctuate with my finances and whims. (I had to hock two of them to pay my income tax this year.) Basically, I have a 12 mm, cheap fisheye (Accura), 20 mm Nikkor, 55 mm Micro Nikkor, 105 mm Nikkor, 200 mm Nikkor, and until recently, a 500 mm mirror Nikkor.

I also carry a Nikonos with a 35 mm lens, a Nikkorex F, a Panon, a Minolta Autocord, and sometimes a Kodak Reflex Instamatic. I use four old Graflex strobes with stands and slaves and a Wein strobe meter. I have a radio-control device and a bunch of electronic and mechanical triggering devices. Finally, I have a Speed Magny 45 and a Gossen exposure meter.

Now to the tools and accessories. They're listed more or less in the order in which they popped into my head, perhaps indicating how helpful they are.

A Rowi C-clamp. Boy, do I love this little under–$5 gizmo. It's essentially a miniature tripod with a swivel head and a clamp part. The camera at-

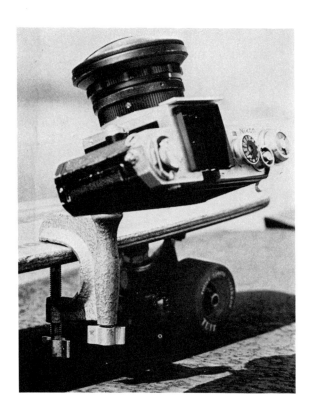

To obtain a skateboard's view of a skateboarder doing a handstand trick, a Nikon F camera was mounted on a skateboard with a Rowi C-clamp. The prism was removed to allow viewing on the ground glass and an Accura-12 mm, circular-fisheye lens was used. The camera's self-timer was set at 10 seconds and the timer release triggered before the skateboarder began his trick. Then he had to hold the handstand until the shutter tripped.

taches to the head, and then the clamp can be affixed to anything handy—a door, shelf, tree branch, skateboard deck, anything. The picture here, showing a fisheye view of a handstanding skateboarder, was made by attaching a Nikon F to a skateboard by means of the C-clamp. The camera's self-timer was set to go off ten seconds after I clicked the start button. The skateboarder then proceeded into his handstand and held it until the camera took his picture.

A set of jeweler's screwdrivers. These are the real tiny ones, the kind needed to tighten the screws on your camera. A regular monthly ritual should be checking the tightness of the screws on your cameras and lenses. You can save a lot of "down" camera time with this simple chore.

A doorbell buzzer and old strobe cord. A doorbell buzzer makes a great hand trigger for motor-drive cameras. The strobe cords nearly always go bad at the camera end, so you can retain the usefulness of one by clipping off the synch end, splitting the wires, and connecting them to the doorbell buzzer. Now you have a cord with a male household plug end.

A long extension cord. You connect the cord you just made to this extension cord, male end to female end, naturally, and then the other male end to your motor-drive Nikon. This device is fine for triggering the camera at distances of 20 feet or so (up to a mile if you have the cord).

A roll of duct tape. This comes in very handy for securing anything from

a light to a camera. Just don't leave the tape on anything you value for very long; the sticky goo comes off.

A hard hat. I carry this just in case the industrial area I'm visiting has a "hard-hats-only" area.

A hammer, some nails, and some wood. These are great materials for creating make-shift tripods in connection with the C-clamp. Nail a piece of wood to a tree, attach the camera with a C-clamp, and you have an instant tripod.

A unique view possible only with a camera clamped on a skateboard. Data: Nikon F, 12 mm Accura fisheye lens, 1/60 sec. at *f*/16 on Tri-X film.

A microscope and telescope adaptor. Both devices are available from Edmund Scientific Company, 660 Edscorp Building, Barrington, New Jersey 08007. Edmund puts out a catalog of interest to all addicted gadgeteers, free for the asking. The adaptors are about $9 and $7.25, respectively. You'll also need a T-adaptor at about $7, if you don't have one. With the adaptors, you can take pictures directly through a microscope or telescope.

A BR-2 Macro ring. This allows you to reverse wide-angle lenses on your camera for extreme close-ups. A 24 mm lens reversed will produce a half-frame size enlargement of an ordinary ant. You'll need to shoot a test roll to determine exposure, however, since a lot of light is lost in the reversal. The ring costs about $10 and is made by Nikon.

A Komura lens extender. The 2X model is best. It doubles the focal length of any lens to which it is attached. (A 50 mm lens effectively becomes a 100 mm lens.) It is best for lenses of 85 mm or more focal length. There is some loss of definition and contrast, but at about $35 the price is worth it to avoid filling those holes in your lens collection. The doubled focal length will cost you two f-stops, though (1/1000 sec. at f/4 instead of f/8).

A ballpoint pen. I use this for taking notes and for depressing the little button that releases the prism housing on a Nikon F. Without the eyelevel prism, you can view a scene directly on the ground glass. This is advantageous for low-level viewing and shooting. The notetaking includes such details as who's in your pictures. Editors appreciate knowing these details.

An electronics repair box. This is only necessary if you're into electronics like I am. If you are, you'll find your equipment often needs repairs at the exact moment you want to use it. So I carry a soldering iron, solder, a wire stripper, a clipper, and assorted resistors and diodes.

An umbrella. For rain and for strobe bounce a white umbrella is ideal.

A changing bag. Film sometimes breaks inside the camera and must be unloaded in the dark. A changing bag on the scene will be invaluable.

A storm suit. These cost about $15 and are a heck of a lot better than a plastic raincoat. You might not need one where you are, but I promised to let you know what's in my trunk, and it's always there.

An old pair of sneakers. Sometimes I have to go wading for my pic-

Here's what you would find in many a professional news photographer's trunk clockwise from top: an electronics repair kit kept in a fishing tackle box; a long extension cord connected to a doorbell buzzer for manual triggering of a motor-drive camera; a set of jeweler's screwdrivers leaning against the tool box; a BR-2 Macro ring for reversing wide-angle lenses for closeup work; a telescope adaptor; a microscope adaptor; and a hard hat.

ture. And leather shoes don't take well to wading in salt water.

An old pair of Army boots. I also occasionally have to go hiking for my picture. Leather shoes don't take well to cow manure.

A tear gas mask. It came in handy during the riotous '60s, but I haven't used it in a long time.

Jumper cables ... and a bunch of assorted wrenches, screwdrivers, and other mechanics tools.

That about sums it up for the useful items I keep on hand. But I've also got my share of ridiculous pieces of junk and some items I consider often misused. For instance:

Filters. There are times and places to use filters, but I don't like seeing a yellow filter on a lens all of the time. A filter is just one more glass element to degrade the image. I bet the guy who uses a filter indoors also wears dark glasses in the office.

Trick items. This includes anything that costs more than a buck. A "star" filter effect can be had by placing two pieces of cut window screen over the lens. Diffraction grating is available in plastic sheets that cost a few cents, instead of those expensive "rainbow" filters. Don't waste money on "trick" accessories.

All air syringe blowers. I've never found one that works. The dust always stays right there on the lens front until I stick my finger on it and smear grease on the lens. Then I have to wipe it with tissue paper. Try a small cosmetic brush instead.

A pneumatic air release. These work, but they only allow one shot at a time. I've never needed mine since I bought the motor drive.

Moiré patterns. These are trick devices for producing psychedelic effects in prints. They don't work worth a darn. Forget them.

That's about it. Let's see, there's also a bunch of cannisters for film that I tossed in there, a spare tire, four skateboard wheels and five bicycle sprockets, a . . .

31

You Need an Umbrella

I have a six-year-old son and one of our favorite pastimes is a game in which I hand him an object, perhaps a stick, and ask him to make up uses for it. The mind of a youngster is quick and agile, uninhibited by adult cautions bred from it-won't-work comments, and his uses are often highly imaginative.

If I handed you an ordinary white umbrella, what photographic uses for it could you find? Three immediately come to my mind:

1. As a source of bounce light using one strobe for portrait work.

2. As protection when coupled to your camera in light rain showers.

3. As a weapon to fight off the hordes of little kiddies who yell "take mah pic-cha" at you.

I'll concentrate on the first two.

While older photography textbooks preach the doctrine of three-light portraiture, many photographers today swear by the single light.

Most of you are probably at least partly familiar with the concept of umbrella bounce light. Reflectasol makes professional bounce umbrellas that provide a beautifully soft illumination on your subject. But the cost of those folding umbrellas, stands, and clamps puts them out of the class of many photographers—including me.

So I set out to duplicate the effect, while using much less costly devices. The search for a suitable umbrella was much simpler than I had first anticipated. There were so many white um-

A strobe head is attached to a tripod with a Rowi C-clamp and is aimed at an open umbrella, also held in place by the C-clamp (top). The light from the strobe is bounced from the umbrella onto the subject, resulting in diffused light. Two O-ring clamps hold the open umbrella to a strobe bracket while the umbrella shields the photographer from rain (bottom).

brellas on the market that the deciding factor became the shape of the handle. Choose a straight, flat handle—not a curved one. The umbrella should be a "normal" one, not bell-shaped, and not one of the smaller models now on the market. Mine cost about $3.

The next item you will need is a photographic C-clamp. I use a Rowi model that cost only a dollar or two many years ago.

Finally, you need to use your tripod, an item you probably already own.

To set up bounce light into an umbrella, follow these steps: Open up the tripod and erect it to a height above the eye level of your subject. Open the umbrella and lay the handle across the flat top surface of the tripod with the C-clamp. Attach the strobe head to the C-clamp, swivel the head toward the open umbrella, tilt the umbrella toward the subject, and you're ready to connect strobe to camera and start clicking.

The light loss will be about two f-stops. That means you use two f-stops more (wider) than you would use if the strobe were pointed directly at the subject from the same distance.

Direct strobe creates stark shadows, seen in this portrait at left. But umbrella-bounced strobe is soft, creating open shadows containing good detail (right). Both pictures were shot with the strobe in the same location.

But marvelous things happen to the light when it strikes the umbrella. It bends and twists and wraps itself around the subject, eliminating harsh shadows in the process and appearing as if multiple lights had been used.

It is particularly flattering to female subjects, who can be made most unattractive by single strobe light blasted into their faces. The single light tends to create shadows even in skin pores. It's fine for a rugged he-man portrait, awful for beautiful women.

But the umbrella works well with both subjects. Women are flattered by the soft, shadowless light. Men appear to have a sensitive quality.

The umbrella strobe device we have described here is quick to set up and break down, easily carried, and easy to use. If you own a strobe meter, exposure can be pinpointed exactly. If

you do not, then shoot a test roll of film to find the proper f-stop. Once this f-stop is found, use it all of the time, since portraits are generally made from the same distance each time.

And with the setup I described, each component performs other valuable functions for you. The C-clamp doubles as a mini-tripod for camera or light. The tripod, of course, is frequently used. And the umbrella?

You've only just begun.

How often are you called out in a drizzle or light snow to take an accident picture? The answer is all too often, since cars seem to collide more in this type of weather.

You need protection. Your camera needs protection. But every photographer knows how difficult it is to juggle a camera, flash, and umbrella while focusing, changing shutter speeds or f-stops, and staying dry. The answer is to secure the umbrella to the strobe bracket attached to your camera.

You can purchase two O-clamps at a local hardware store. These are tightened by turning a screw that draws a metal band in a smaller circle. Attach the clamps to your strobe bracket and slide the umbrella handle down through the clamps. Now tighten them.

This combination works well in situations without gusty winds. You're on your own in windy situations!

32

A New Darkroom Technique

I have likened darkroom experimentation to the excitement of scientific research. That kind of excitement is rare, usually accompanying the discovery of a new process to produce an unusual picture.

It happened to me again recently.

I was working on a layout of skateboarders, those four-wheel enthusiasts of paved waves. All the expected—and a few unexpected—pictures had been produced, and the newspaper's appetite was satisfied.

Then I began to "mess around" with a picture. The picture had been made at night, with strobe lighting. It showed a boy going off a ramp and "wiping out" in mid-air. I didn't think it was exciting enough in itself. It just happened to be a handy negative for experimentation.

I began by making a sizable blowup of just the skateboarder, excluding the ramp and a bit of foreground. The straight print is reproduced here.

I dried the print and returned to the enlarger. This time I placed this straight print face down on a new sheet of enlarging paper, stopped the enlarging lens down two *f*-stops, and exposed for six seconds. This exposure yielded a paper negative, also shown here.

That still wasn't good enough.

I tried the process again, but this time stopped down one more *f*-stop, exposed six seconds with the paper positive stationary, and three seconds while I moved it slowly. The developed paper

When a straight print is laid on top of a new sheet of printing paper and exposed through an enlarger's white light, it produces . . .

A straight paper negative. But to create the effect of motion . . .

The straight print was moved during the exposure of the paper negative image, producing the blur you see here. Then this image was used as a paper negative . . .

And exposed from the moving light of a small fiber-optic flashlight. The flashlight moved in unpredictable swirls, creating the black-and-white background pattern. This final print recreates the dream world associated with skateboard tricks.

negative had just the right amount of blur for my taste.

That print was dried and placed face down on still another unexposed sheet of printing paper. I exposed for six seconds and developed it. It was good, but something was still missing. It looked too much like the original version.

I wanted a print that would create what goes on in the mind of a skateboarder. They speak of "another world," as if they journey somewhere during their skateboard trips. I wanted a print that reflected this "other world."

So I picked up a fiber optic flashlight for about $2. This device throws a narrow beam of light. It was like a magic wand. I could wave it over the print, stopping where I wanted to, moving slowly or rapidly, swirling the light. I could be free of the enlarger's steady blast of light.

A kind of madness that I call darkroom fever took over. I must have ripped through 10 sheets of paper in 15 minutes. Each one produced a slightly different effect.

Some had the appearance of brain texture, with squiggly lines. Others were like the light at the end of a tunnel. Some looked like a foggy evening.

I now pass the technique on to you for your adaptation. I've never heard of it being done before, and I was tremendously pleased with the off-beat effects I could achieve.

33

Neither Rain, nor Snow, nor...

Whether it's good weather, bad weather, or no weather, editors want pictures of it. Let's consider the many special weather situations you'll be called on to photograph and the types of pictures and precautions you need to know how to handle.

Fog. This is one of nature's most beautiful phenomena, yet one of the most difficult to capture satisfactorily on film. The basic problem is that fog causes light scattering and in such conditions, your exposure meter may not be completely reliable. Some photographers can't believe the meter is telling the truth anyhow, and the result is usually overexposed negatives.

If the fog is a light one and you want to emphasize it, then attach a blue filter in front of your lens. Blue tends to increase the appearance of haze or fog, while a light yellow filter (or a UV or skylight filter) decreases the effect of fog.

In composing a picture of a foggy day, try to include an object that disappears into the fog at a distance—such as a bridge or a pier. Or try to include similar objects shown at different distances, such as trees, that will clearly illustrate the degree of fog present.

Fog can also be dramatic at night, with light shafts visible through tree branches. A typical time exposure of about eight seconds at f/5.6 will capture most foggy night scenes.

After having your camera out in

Fog can be portrayed quite effectively at night, as in this picture. The camera was positioned so that shafts of light would filter through tree branches, and so that trees would overlap to give an impression of depth. Data: Nikkorex F, 50 mm lens, eight seconds at $f/5.6$ on Tri-X film.

the fog (where the humidity approaches 100 percent), be sure to dry it off when you return indoors. Take off the camera back and blow-dry the entire camera with a hair dryer.

Rain. If at all possible, keep raindrops off the camera and lens. Drops on the front element of the lens will result in blurred areas on the negative, perhaps ruining the picture. Moisture in any form is a deadly enemy to cameras.

When carrying the camera in a rainstorm, keep the lens facing your chest to minimize chances of raindrops striking the front element. Carry an extra handkerchief with you to dry the front element.

In composing a rainy-day picture, perhaps you can find a sheltered area to shoot from, such as a telephone booth, store awnings, or doorways.

A slow shutter speed may capture rain more clearly than a fast one, when the drops are shown against a dark background. Strobe flashed into rain will reflect back into the camera from the nearby droplets, resulting in speckled negatives that to many mean rain.

There are several ways to illustrate rain. One of the most popular today is shooting through a car windshield. This produces blurred images, and you'll want to be sure the scene in the distance is recognizable despite the blur. You can also shoot through home windows dotted with water. A wide-angle lens will keep foreground and background in focus at the same time. You can also make a double exposure, shooting the raindrops first, and then refocusing to shoot the background a second time on the same negative.

Try close-ups of rain splashing in puddles. Shoot a close-up of a rain-covered face. Watch for kids playing in the rain. And keep an eye out for interesting reflections on wet streets.

If the rain is blowing, you probably should put your camera inside a plastic bag or a special bag made for such conditions. If you use a grocery-store type plastic bag, cut a hole for the front lens and secure the plastic to the lens with a rubber band.

Dry your camera with a hair dryer when you return home.

Wind. Wind is invisible. You'll need a "prop" to illustrate nature's most gentle breeze or unruly gale. Trees are perhaps the most obvious prop, but let's consider others. How about flags, swaying stop lights, bending signs, human hair, water splashing against a seawall, kites high-in-the-sky, a person leaning into the wind while crossing the street? All of these help say "windy day."

For photographers, wind has an unwelcome companion—dust. Dust is as dreaded an enemy of cameras as is moisture. Avoid dust, if at all possible, with any camera except the Nikonos. The Nikon F, incidentally, has poor dust sealing. The dust will settle to the bottom of the camera and gum up the slow-speed gearing.

Dust is best pictured from afar, with a telephoto lens compacting and exaggerating the problem, much as such a lens does with fog. After having your camera out in dust, strip it down and brush out the inside as carefully as you can.

Heat and Humidity. What a combination this is. If you face an assignment in an area of high temperatures and nearly equally high humidity readings, then you should take some precautions with your equipment. Humidity can be beaten by keeping your equipment in a styrofoam picnic hamper in which you've placed some silica gel, or dried rice. Both will absorb moisture that otherwise would seep into your camera gear.

Keep your film in the factory canisters until it's needed for shooting.

One of the worst conditions to photograph is a sandstorm. Sand was blowing at 50 miles an hour when this picture was taken from the shelter of a parked car. Never expose a normal camera to such conditions. Data: Nikon F, 200 mm lens, 1/1000 sec. at f/5.6 on Tri-X film.

Whatever you do, keep your camera out of prolonged contact with direct sunlight on a hot day. The temperature in a closed car on a summer day in Florida can reach in excess of 160 degrees. That kind of heat ruins film emulsion, dissolves camera lubricants, and hastens discoloring of lens coatings.

You should also remember never to leave your camera lens facing the sun. The light will stream through your lens, focus on the shutter curtain, and burn a pinhole through it. The effect is the same as focusing a magnifying glass on dry grass or paper—fire!

For pictures to illustrate a heat wave, you can try close-ups of sweaty faces, a beauty in sparse attire, or sun glinting off an object in your picture. Heat waves that shimmer off highways can be exaggerated by shooting an approaching car through a telephoto lens, with the camera held at near-ground level.

Try to keep your own sweat from coating your camera. Your body moisture contains a combination of salt and acids, both of which do evil things to camera parts. If your camera becomes sweaty, wipe it off and then clean the body with a water-soaked Q-tip or other cotton swab.

Lightning. Time expose lightning at $f/11$ for the duration of the flash or flashes. Try to compose the picture so that some ground object, such as a city skyline, is visible. And don't become the high spot on the ground from which you're shooting. Your body, camera, and tripod look like a lightning rod to those electrons bouncing between cloud and earth. A direct hit will certainly ruin your picture—and you.

Thunderstorms. The storms themselves are often awesomely beautiful as they approach in a squall line. Find an open spot, or shoot from atop a high building, as the clouds begin to roll in. Sometimes you'll be able to capture a panorama where some clouds are streaking rain to the ground, while others appear pregnant with moisture. You can burn in areas on your final print to make the storms appear even more threatening.

Hail. Shoot from a protected area when a hailstorm strikes. Hailstones have reached baseball size many times and can seriously injure anyone or damage anything they strike. Unless the hailstones are unusually large, you may need to use a telephoto lens to pick up bouncing hailstones on pavements. If the storm leaves a heavy deposit of hail behind, try for pictures that relate the depth of the ice to known objects, or to people having fun. Look for damage pictures following the infrequent severe hailstorm. Crops are particularly hard-hit by such storms.

Snow. Protect your camera as in rain. But unlike rain, snow can be easily photographed by the cover it leaves

behind. A blizzard is difficult to picture, but try applying the same rules as for fog. Shoot from protected doorways as much as possible. Brush snow off your camera with a typewriter brush. Place swirling snow against a dark background to make it stand out. A strobe will also bring out snowflakes against a darker background.

Hurricane. This, the most severe type of storm, is a combination of rain, wind, lightning, and thunderstorms. The power of a full-grown hurricane is almost impossible to describe. It is the other side of awesome.

As the wind picks up when a hurricane nears your area, you should find protected locations from which to shoot. In early stages, a telephone booth is fine, or shoot through a car window opened on the side opposite the wind. Always be alert for power lines above you that may snap and drop onto you. Stay away from hurricane-whipped waves. They have such power you simply cannot stand up in them.

For your own protection, wear a full storm suit. Boots are okay unless you'll be around wet rocks, then wear sneakers that grip. Use a Nikonos camera if you have one or can borrow or rent one. If not, wrap your own cameras tightly in plastic bags to protect them from wind-driven rain.

A hurricane goes through several stages. Very early, the sky becomes steel gray and the clouds scuttle low. A light rain may begin to fall. People in coastal areas begin evacuation and boarding up, and much of your hurricane photography will be done under these not-too-serious weather conditions.

The wind builds slowly at first, and then rapidly. A rule is to pull out of coastal areas when the wind reaches a sustained 50 miles an hour. Hurricane-strength winds are 75 miles an hour, but don't wait for them.

In this weather, final evacuations will be conducted and conditions for photographers are treacherous. Good pictures are difficult to make. Concentrate on people evacuating or being rescued. Then get out yourself.

The full fury of a hurricane is rarely photographed. Conditions are simply too dangerous. If you must capture this stage on film, do so with remotely-operated cameras. You can easily modify a $3 wind gauge to trigger your camera when gusts hit 60 miles an hour. You can also build a simple switch that trips the camera when the switch becomes wet. Or you can use a timer to trip the camera. But don't use your own two hands.

The aftermath is easy to photograph. Just get past the police lines and take your pick of the damage shots.

Before a hurricane strikes, you may want to consider aerial pictures. Should a coastal area be devastated, you can "fly" aftermath aerials for "before and after" pictures.

A few more tips: Watch out for hurtling coconuts, lumber, and signs. I

A little humor here in a not-too-humorous situation—a flood caused by 14 inches of rain in one day. Look for foreground objects or signs to add some humor to your weather pictures. Data: Nikonos, 35 mm lens, 1/250 sec. at *f*/11 on Tri-X film.

An aerial view of a squall line moving in from the Gulf of Mexico. The rain is approaching at the top of the picture. Near the top right and on the bottom left are three fires set by lightning; the fires burn in circles from each strike. Because the Civil Air Patrol airplane from which this picture was taken was bouncing severely in storm turbulence, I had time for only two passes before the pilot said "no more." Data: Nikkorex F, 50 mm lens, 1/500 sec. at *f*/2 on Tri-X film.

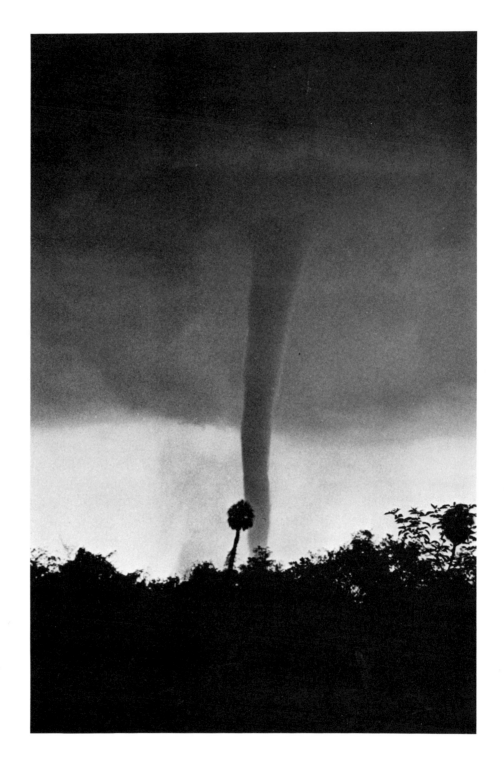

This tornado, one of the
largest ever photographed
in Florida, destroyed
several mobile homes in a
trailer park. Data:
Hasselbald, 80 mm lens.
Photo by Leslie Gaines.

once watched a huge sign chop through the air 10 feet above the ground, making a helicopter noise as it spun in winds above 125 miles an hour. After one hurricane, a piece of 2 × 4 lumber was found driven completely through the trunk of a two-foot wide royal palm tree.

Keep your film in waterproof cannisters before and after shooting. Carry extra handkerchiefs to keep your lens and hands dry. Try to ride with local police as they help evacuate residents before the storm and return to check damage after the storm.

A CB radio tuned to Channel 9 and a police scanner with interchangeable crystals will keep you in touch with the action areas.

Tornado. Getting a good picture of a tornado involves some luck. I hope you can position yourself so that a dark tornado appears against a light sky, or a light tornado against a dark sky. You have my regrets if you see a dark tornado against a dark sky.

You should start worrying if the tornado appears to be standing still. It may be coming straight at you.

Try to show the tornado's size by relating it to ground objects in the picture.

When a tornado alert is sounded for your area, you probably won't have time to go outside and scan the skies for the next several hours. But you can often find out how near a tornado is by using your television or radio.

A tornado produces electromagnetic disturbances that will be picked up by television and radio sets. Tune your radio away from a station in the area of 55 kilocycles. Lightning will be recognized as intermittent static. A tornado will produce constant static.

Turn your television set to Channel 13 and darken the picture until the screen is black. Then turn the channel selector to Channel 2. It, too, should be dark. Lightning will appear as streaks of light across the screen. A tornado will turn the screen white.

The range over which your television and radio will detect a tornado will depend on the antenna sensitivity, but 25 miles is an average for simple antennas. If your screen turns white, you can duck under your desk or run outside to get the picture, depending on your personal fortitude.

34

The Cold Facts

If predictions of meteorologists come to pass, the Eastern United States faces several successive winters of below-average temperatures. They tell us 1977 was only the beginning.

Cold weather like this country faced in 1977 is news with a capital N. And will continue to be front page news as the ramifications become obvious—factories will close, crops will be ruined, industries will come to a standstill.

As a photojournalist it will be your job to venture into the arctic temperatures and bring back photographs to illustrate the spreading disaster.

When you do, you better be prepared. Otherwise, you risk losing your intended pictures—or worse, your camera or your own skin.

If you live in an area that records zero readings with any degree of regularity, then no one has to warn you of the dangers of frostbite. Perhaps I won't even need to warn you that your skin may freeze against super cold metal parts of your camera.

But do you know what precautions to take to safeguard your camera and your pictures?

First, let's explain why you have a problem with your camera in cold weather. The basic reason is that your camera is a complicated mechanism composed of many different metals, and different metals have different rates of contraction. You may remember from physics that heat causes expansion of

metals while cold causes contraction. Inside your camera as different metals contract at different rates, your camera's metal parts may suddenly tighten up.

Lubricants not designed for extreme cold may congeal or freeze. This is less a problem with modern cameras lubricated with silicones, which are good to minus 60 degrees.

But older cameras may need "winterizing." Winterizing is simply removal of all lubricants. Photojournalists traveling to the Arctic or Antarctica routinely have their cameras winterized.

If you live in a cold region and don't want to be bothered with winterizing and the relubricating, perhaps you might want to consider two camera bodies—one for each weather condition. But whatever you do, don't take a winterized camera into the summer heat or you'll ruin it.

The first part of the camera to give you trouble in extreme cold will probably be the shutter. This is particularly true of focal-plane shutters with rubberized or cloth curtains. These shutters tighten up and yield less-than-posted speeds. The result is overexposed film. When taking a camera with a focal-plane shutter into cold weather, make your initial exposures at slow speeds and gradually work up to higher shutter speeds.

But perhaps you'll want to test your individual camera before venturing into cold conditions, or before winter strikes. To do so, first shoot a roll of film inside your kitchen by available light.

Now, put your camera, loaded with a new roll of film, into the freezer of your refrigerator. Leave it there for several hours, even overnight. After that period of time, take it out and shoot a second roll in the kitchen by available light.

Develop both rolls and study them for signs of overexposed negatives on the roll shot after the camera was removed from the freezer.

If both sets of negatives look similar, you're in business and your shutter will probably hold up in most winter weather. If you have a badly overexposed roll from the freezer experiment, however, you'll want to forget using that camera unless you are willing to go to some lengths to keep it warm in field use.

If you deal in really cold weather—below minus 60 degrees—this slowing of the shutter may be offset by a reduction in rated film speed. At extreme temperatures, film loses some of its sensitivity and the net result of a slowed camera and slowed film may be perfect exposures.

If your camera fails the freezer test and you don't want to keep one camera body especially for winter shooting, then you might be surprised to learn that your old box camera may come in handy. These cameras have "loose"

shutters that are less susceptible to binding in cold. Besides, if the camera becomes a total loss for some reason or another, your personal heartache won't be as serious as if your favorite Nikon F had just been ruined.

Any batteries you use will also be quickly affected by extreme cold. Your Cadmium-sulfide (CdS) exposure meter may not come off its peg. If it's the only meter you have, perhaps it will work if you switch from zinc-carbon batteries to alkalines. Instead of the PX-626, try the PX-13 battery.

A better bet is to use a selenium-cell exposure meter. These meters do not rely on batteries and will operate in all extremes of temperature.

The batteries in your Nikon F motor drive may fail, or may operate at very slow speed. Perhaps it would be best if you took the motor drive off and used the Nikon with manual advance. If you must have a motor drive, this is one instance where the detached battery pack will prove superior. Keep the remote pack under your coat, where it can stay warm, and the batteries should operate at normal speed.

Indeed, if you can, keep the entire camera under your coat until you are ready to shoot. This keeps snow off the camera and also keeps the mechanism warm.

Another way to keep the camera warm is to place it in a plastic bag with a handwarmer.

Keep your film in its factory can-nister until you're ready to load and shoot. The colder your film is, the more brittle it gets and the more susceptible it becomes to breaking. That's why a while back, I cautioned against the use of a motor drive. If you are working in extreme cold, you should advance your film slowly with the manual advance lever.

Besides preventing the film from breaking, this also lessens the chance you'll have static-electricity discharge on your negatives. You know that static electricity causes the shock you get when you walk across a carpet and touch someone or a metal object. The same thing happens when your film drags through the camera. You can prevent this by transporting the film slowly and deliberately. You'll recognize static electricity on your film by spider-like marks.

Now with your camera ready, your lens hood on, and your skylight or UV filter in place, let's talk about you, the photographer.

Naturally, you'll want to be warmly dressed. But bulky attire in the vicinity of your hands interferes with camera operation. The alternative is most unattractive—bare hands invite frostbite. Bare skin may freeze to metal. Take heart, there is an answer.

Go to the nearest makeup counter at your local drugstore and purchase some thin cotton gloves. If they don't have any, your photo dealer should, since they are used in handling movie

film. Buy a pair and wear them at all times in cold-weather photography conditions.

But they won't keep your hands warm. So I suggest you order a pair of special mittens made for photographers. These are available at about $5.50 a pair (plus $2 shipping and handling) from Porter's Camera Store, P. O. Box 628, Cedar Falls, Iowa, 50613.

These mittens have two slits in them that allow you to slide your thumb and fingers from the mitten while handling the camera, and then to quickly return them to the warmth of the mitten.

You may still have difficulty with the camera controls. Go back to your local photo dealer and buy an over-size, screw-on shutter release button ($2–$3). These are sometimes called soft-touch buttons, but they'll allow you to trip the shutter with even bulky gloves on.

You can also purchase some vacuum cleaner belts in a size that will fit around your lenses' focusing rings. These cheap belts improve quick handling even without gloves, but are of immense help when you are wearing gloves or mittens.

Oh yes. Don't forget to wax your camera strap. Leather weakens in cold weather and the strap may snap at an inappropriate moment. You could switch to a metal carrying strap as long as it won't come in contact with your skin.

You'll also want to prevent your delicate eyebrow area from coming in contact with metal around the viewfinder. If you have an expensive sports-finder that shows the entire field of view from a viewing distance of several inches, then you have no problem. But not many photographers can afford them. So you'll want to take your faithful gaffer tape (duct tape) and thoroughly tape off the metal around the viewfinder. Or use a rubber eyecup.

Okay. If you've followed all the instructions so far and your film still comes out with static discharges on it, switch cameras. A roll-film camera is less likely to give you this annoying problem because the paper backing on the film retains enough moisture to hold down static buildup. The same is true of a cartridge-loading camera.

You may find a new use for those old Minolta Autocords, Rolleiflexes and Kodak Instamatic Reflex cameras—all fine pieces of equipment. If you own a Nikonos, it should be an obvious first choice for winter duty. If you don't, remember what we said earlier about the old box camera.

Happy, brrrrrr, shooting.

Index